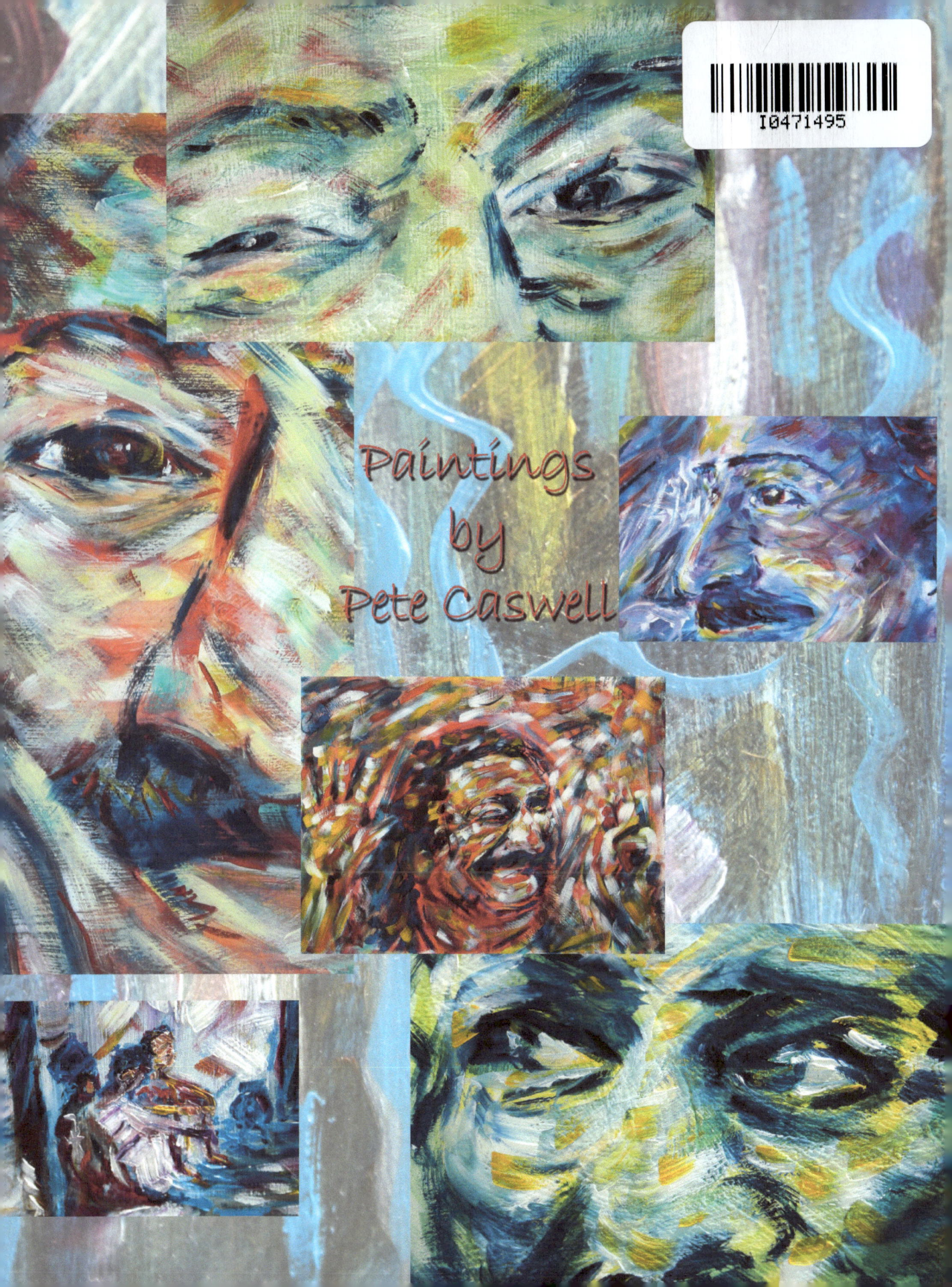

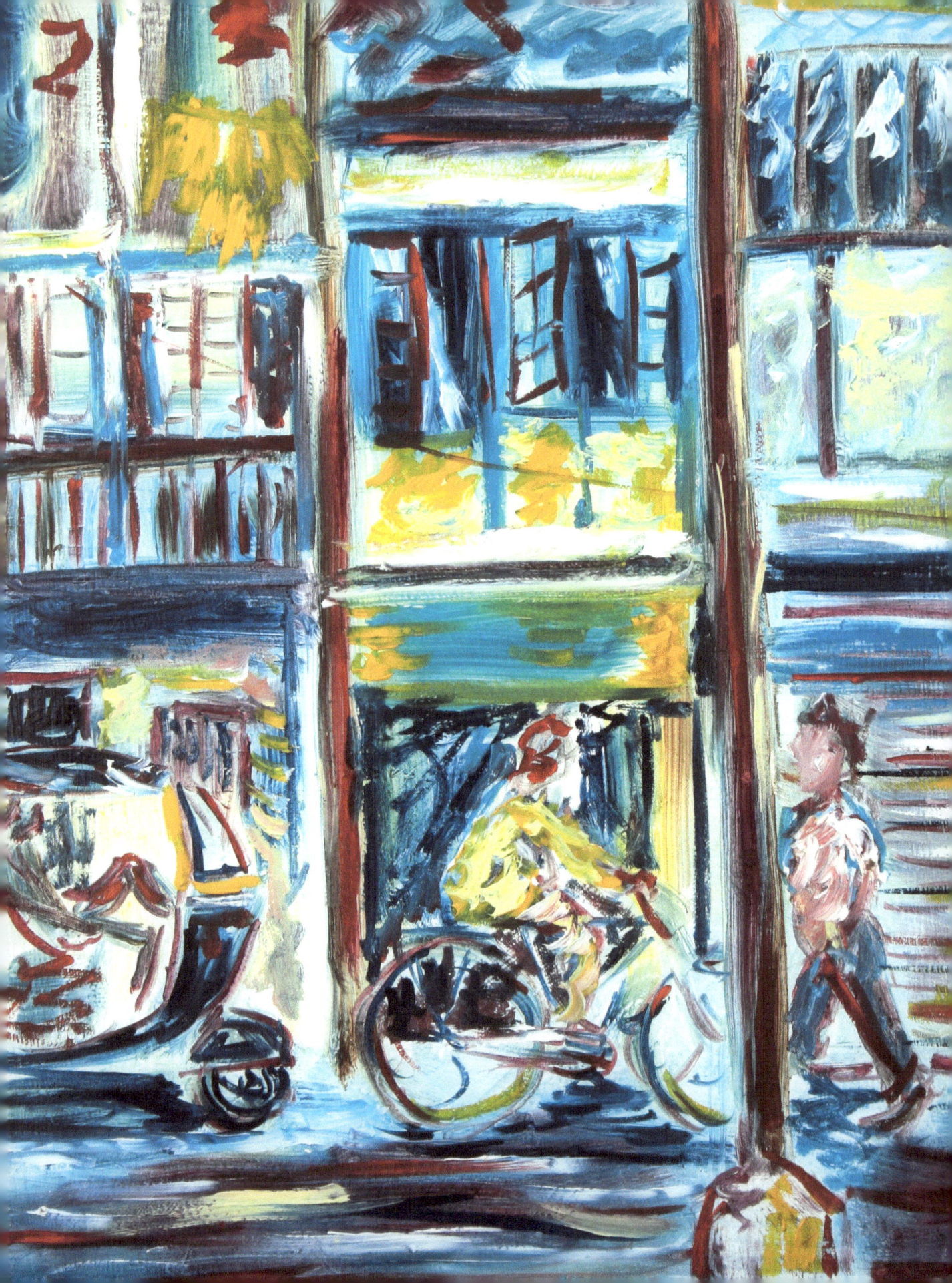

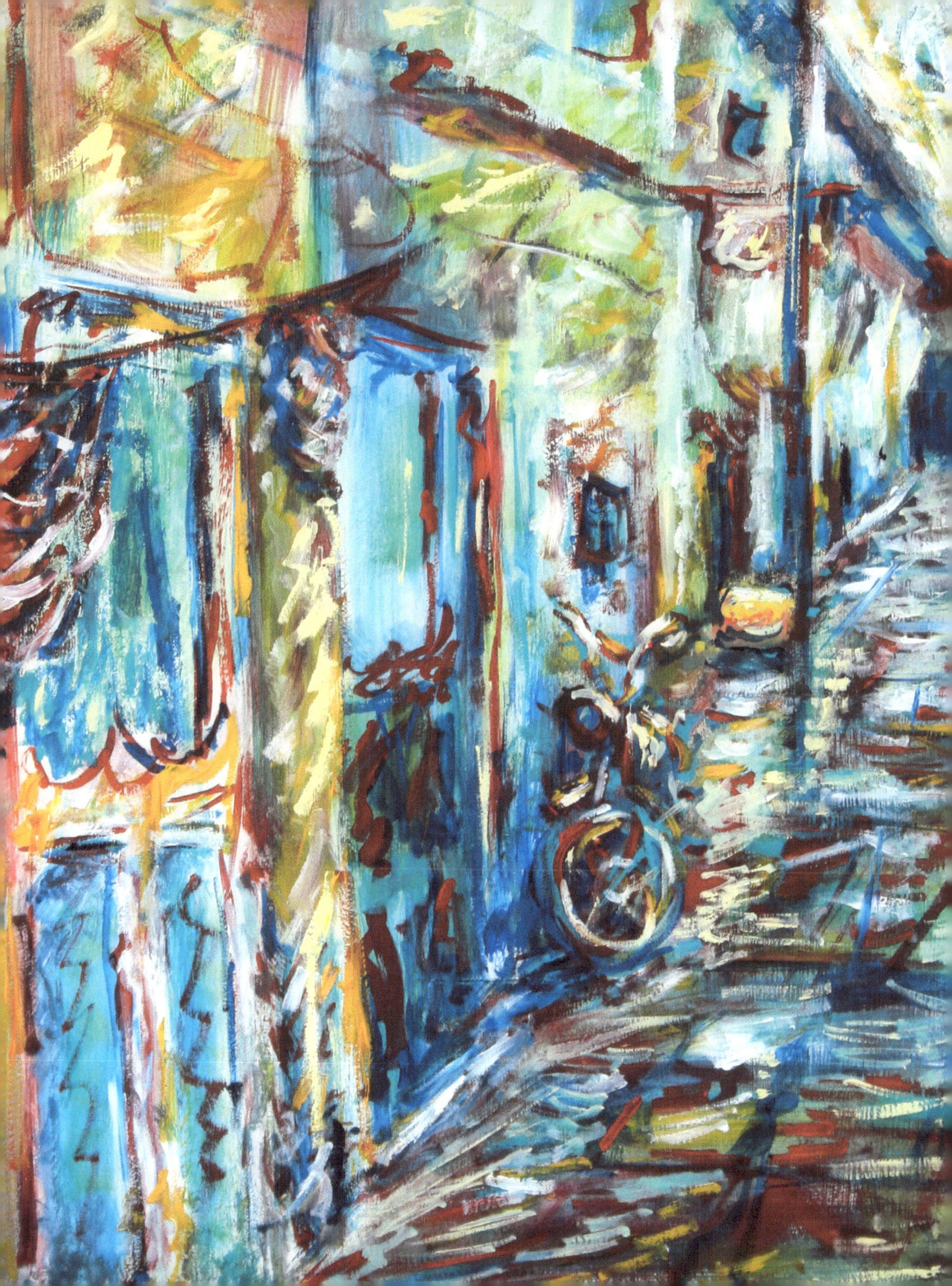

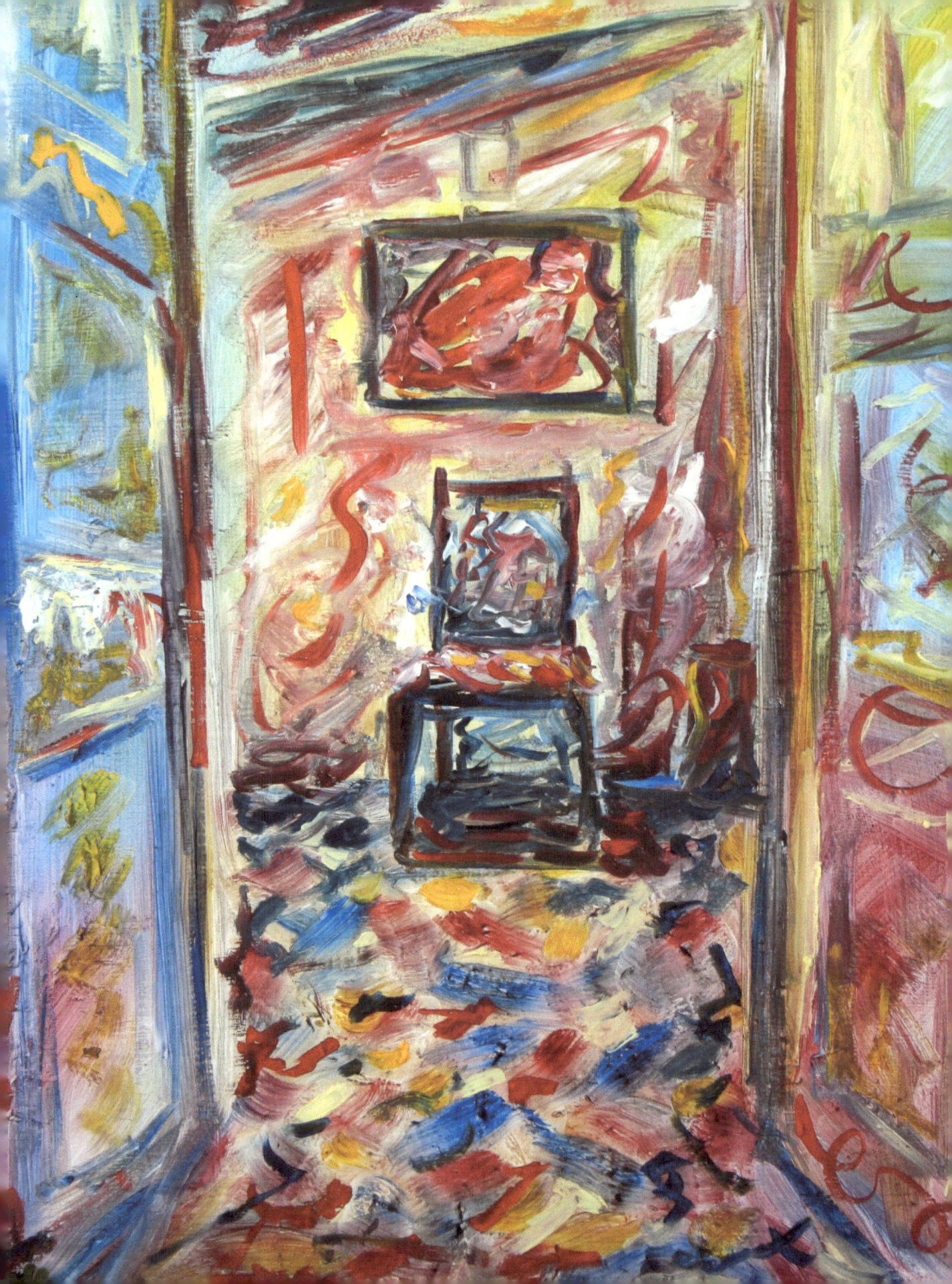

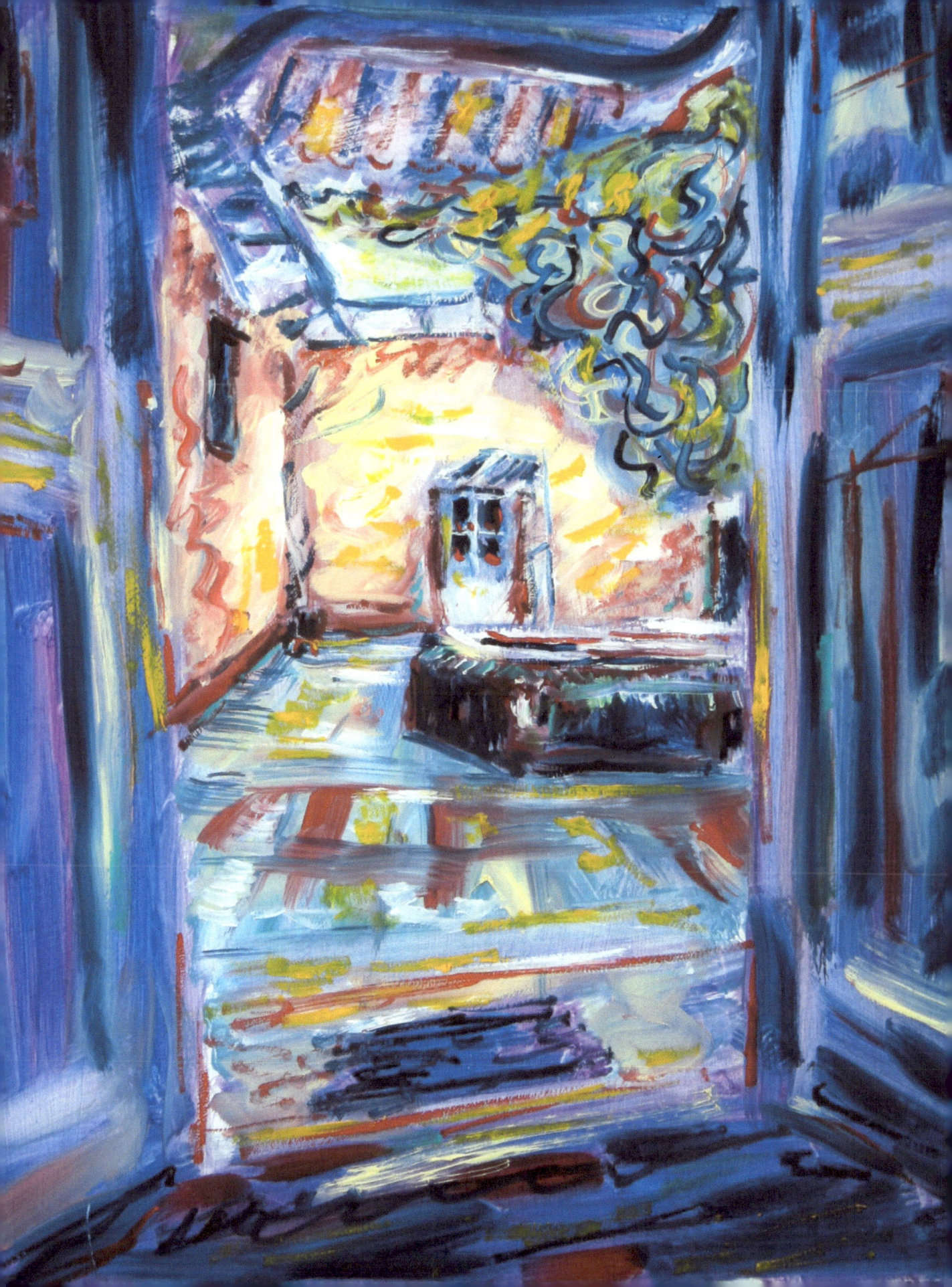

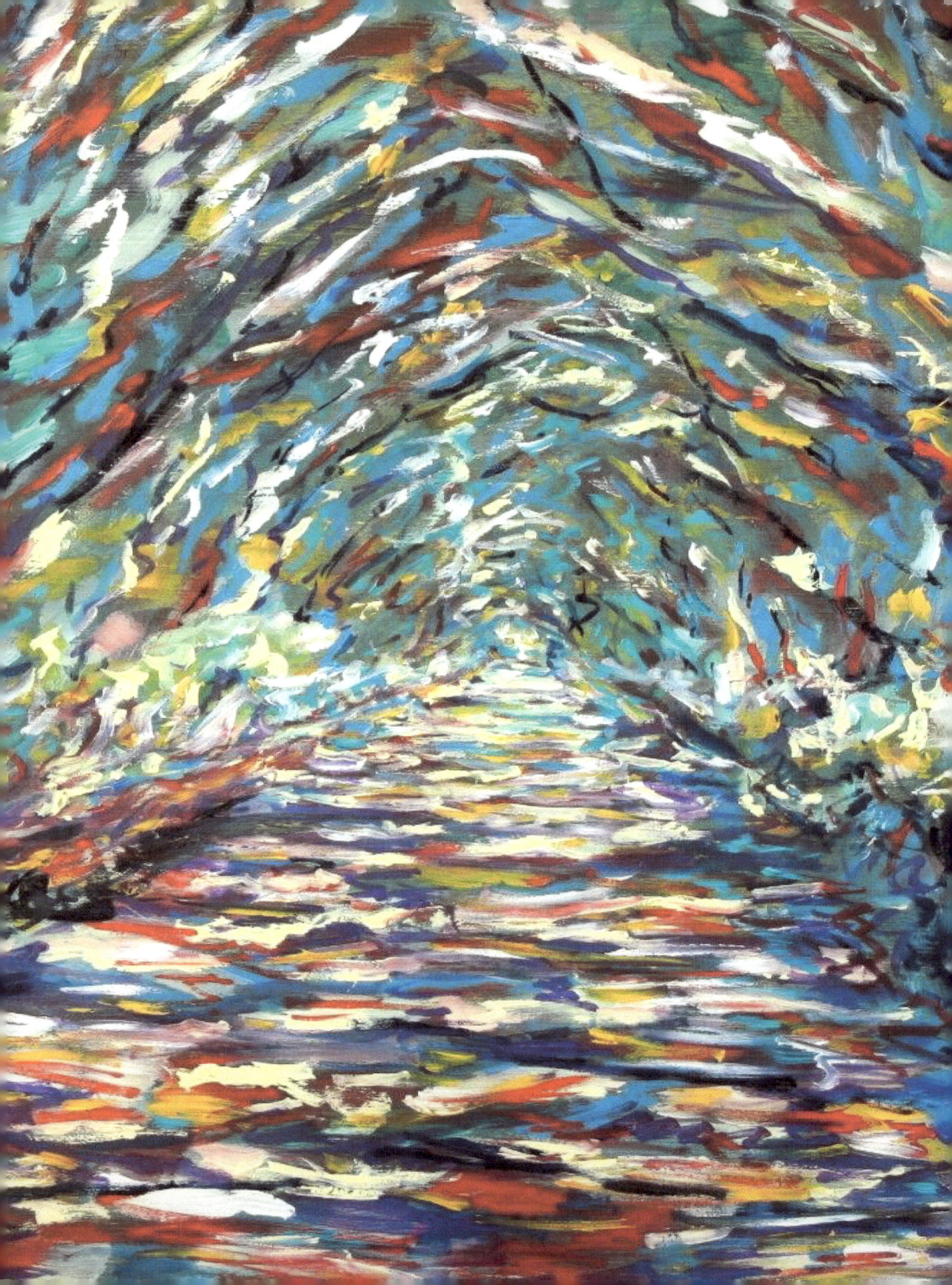

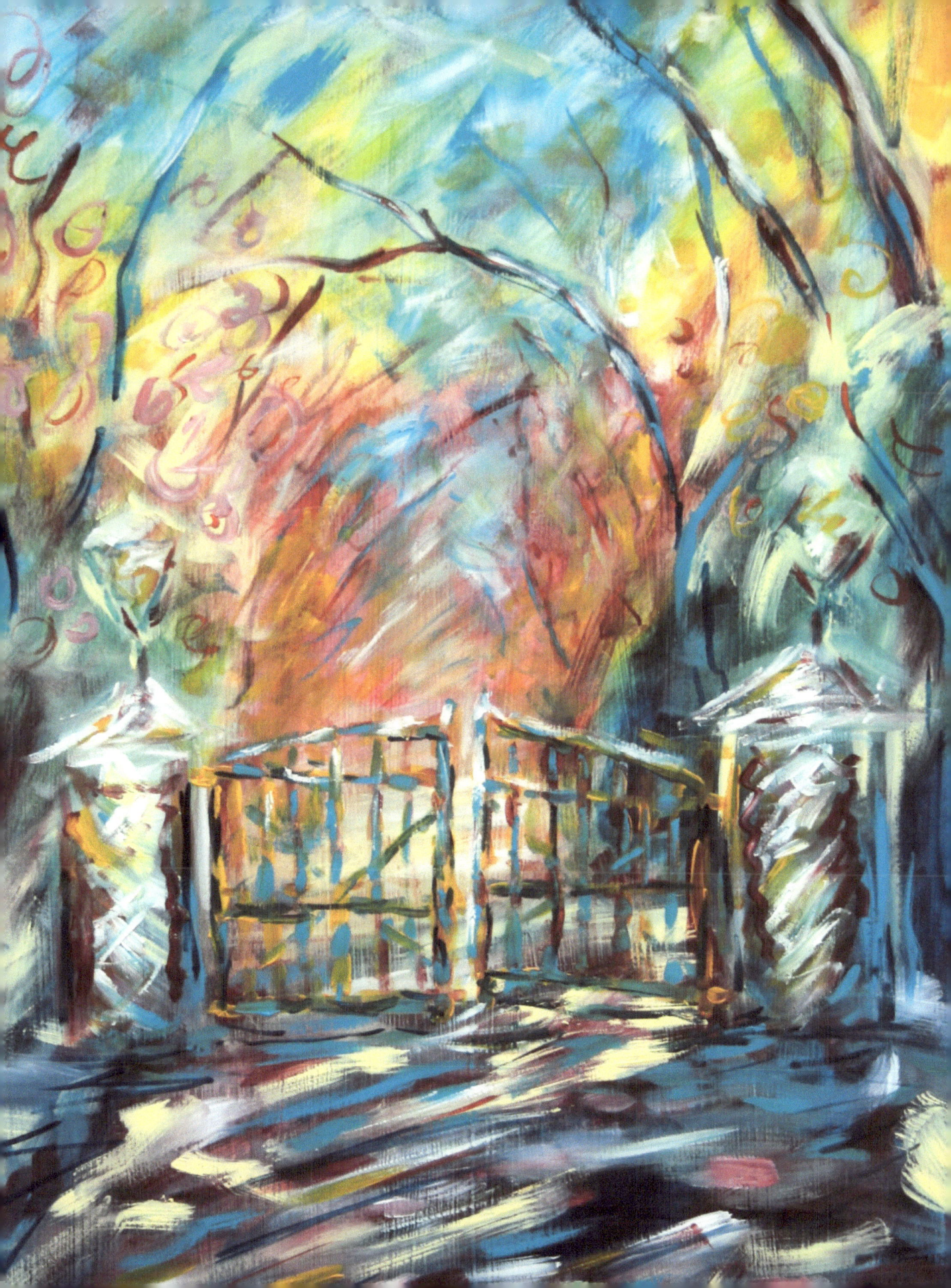

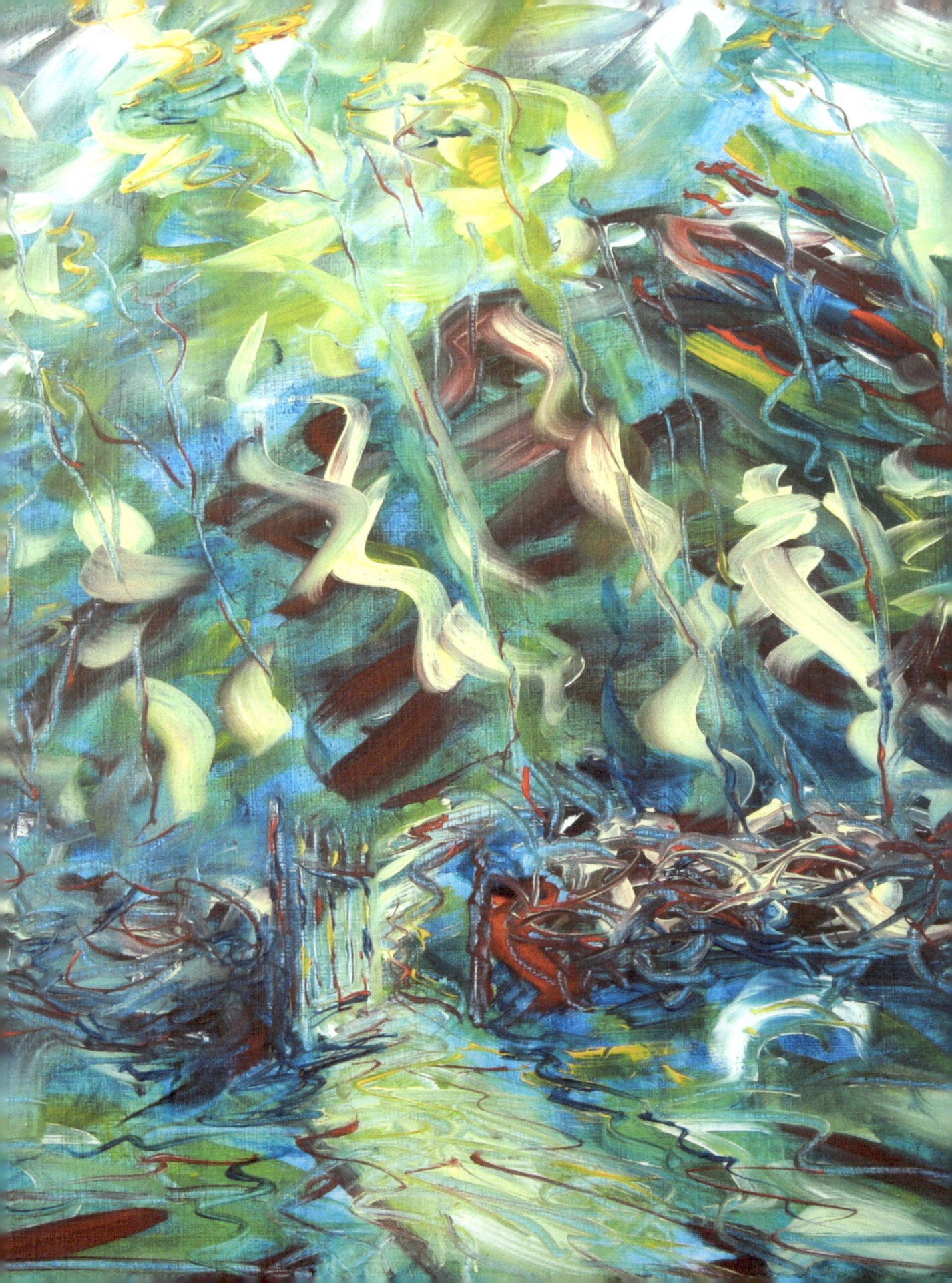

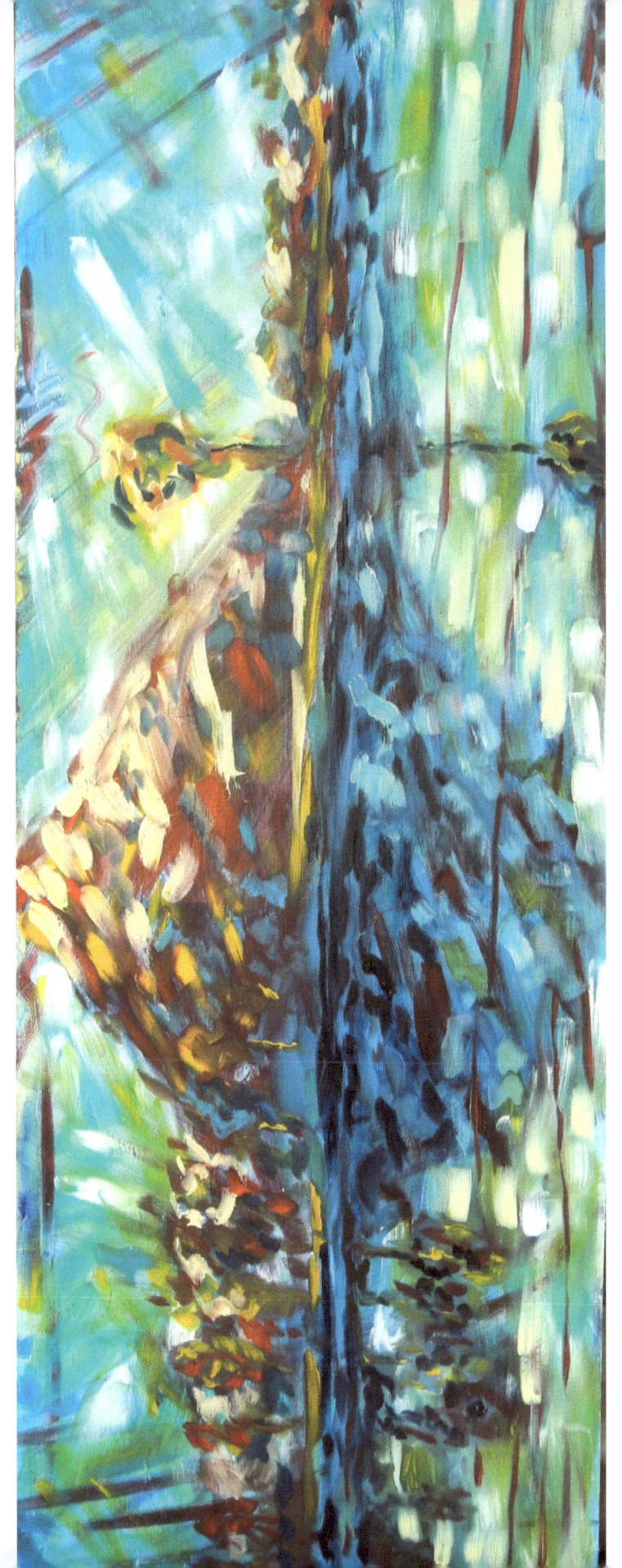

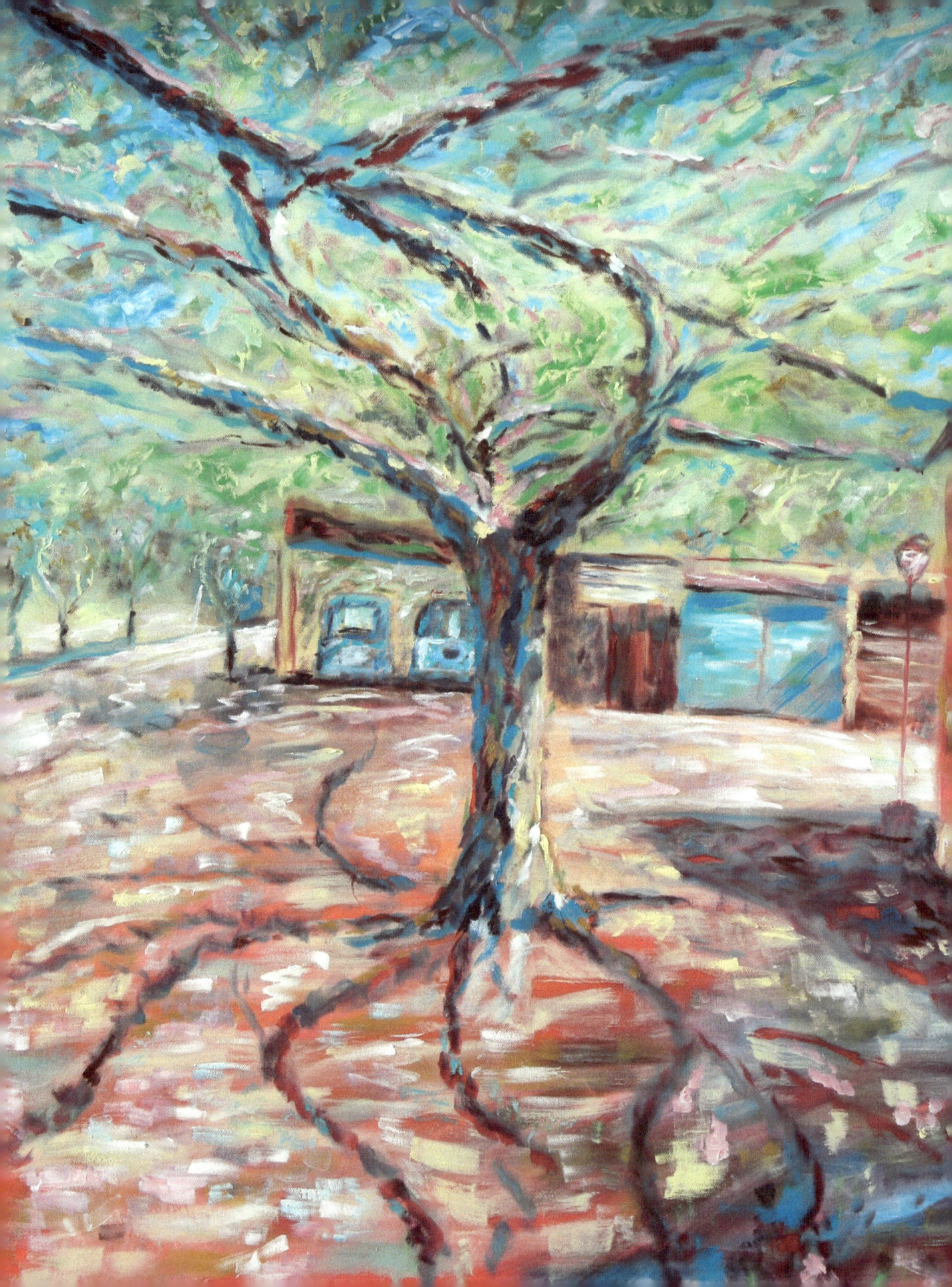

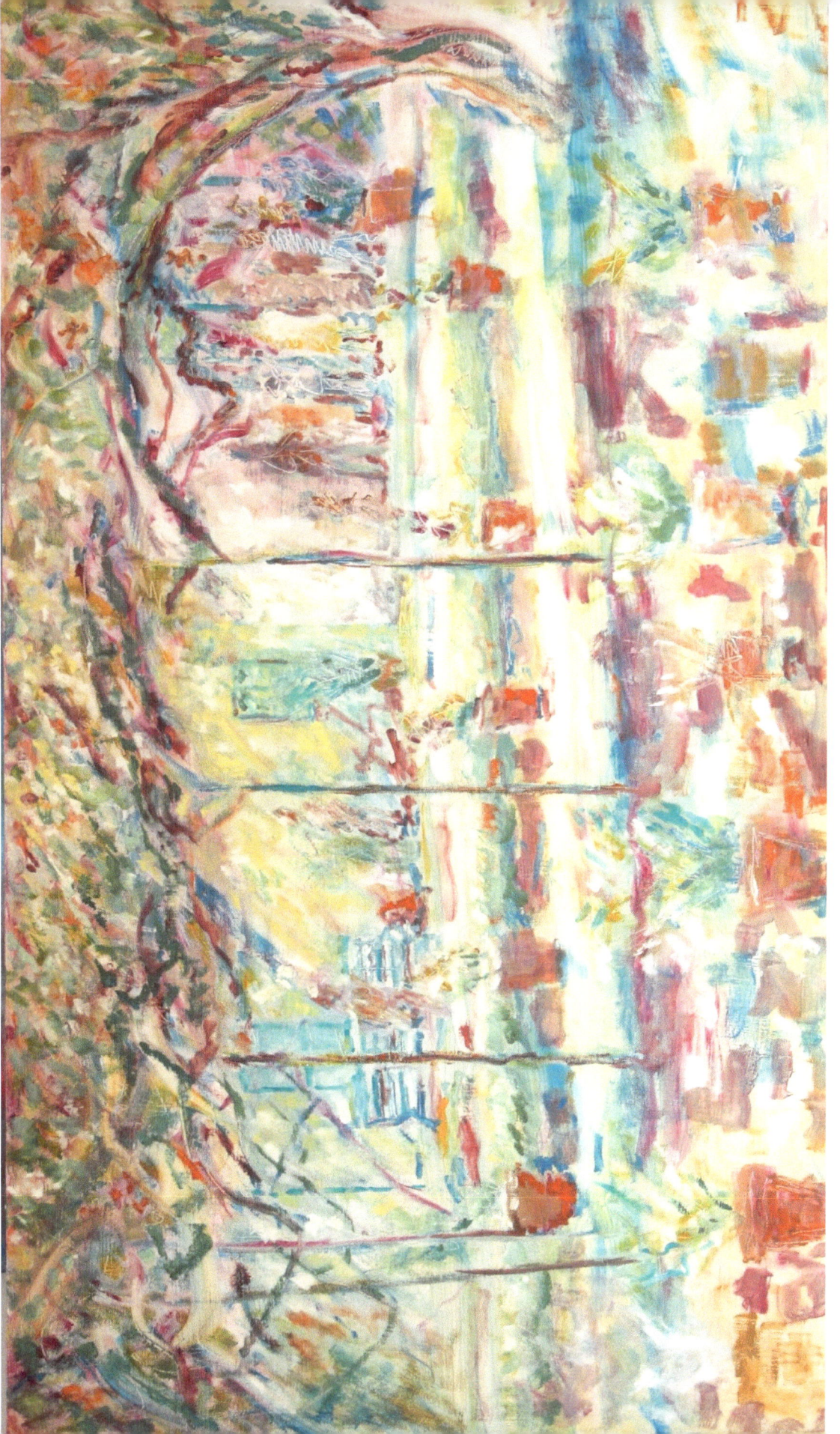

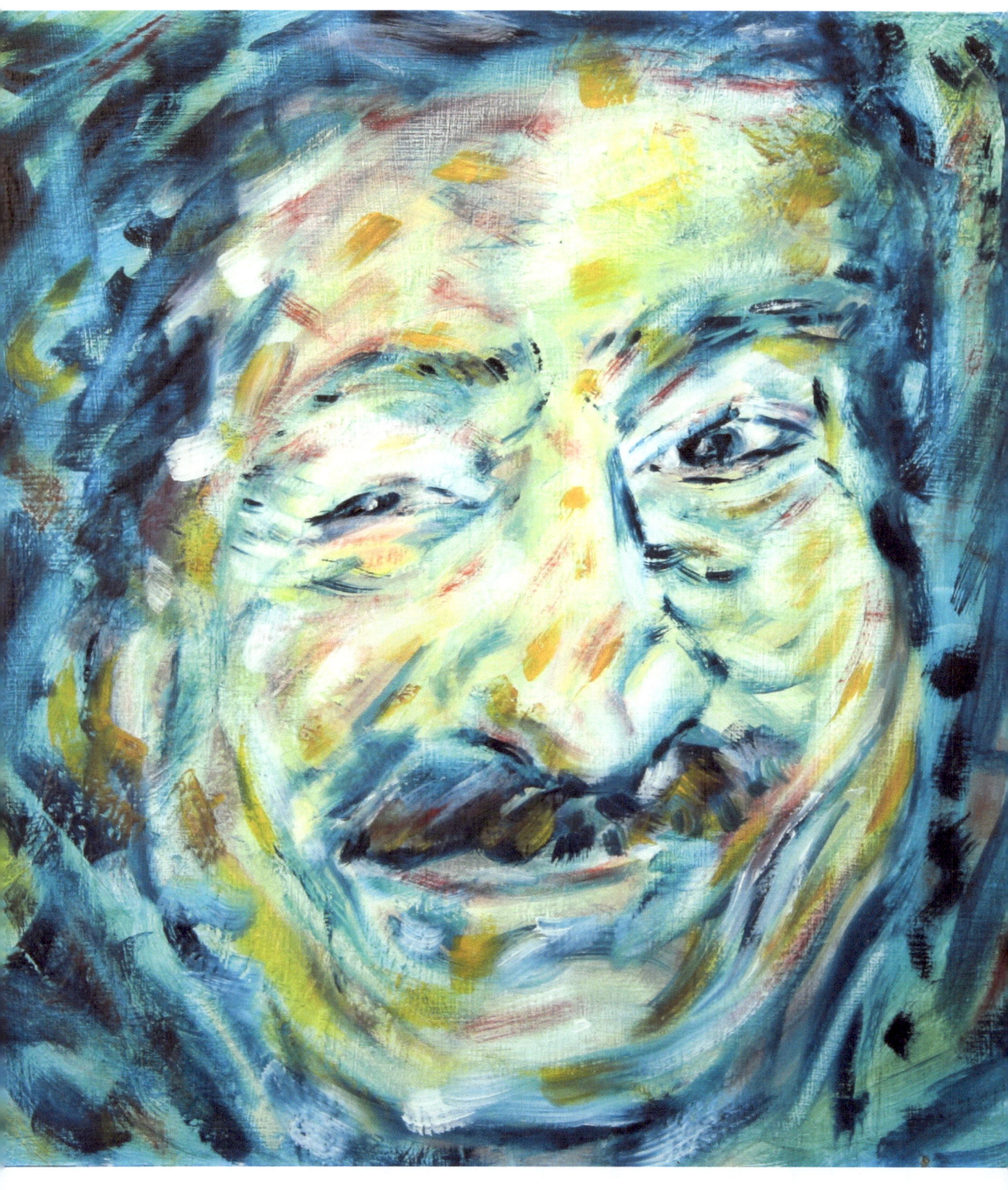

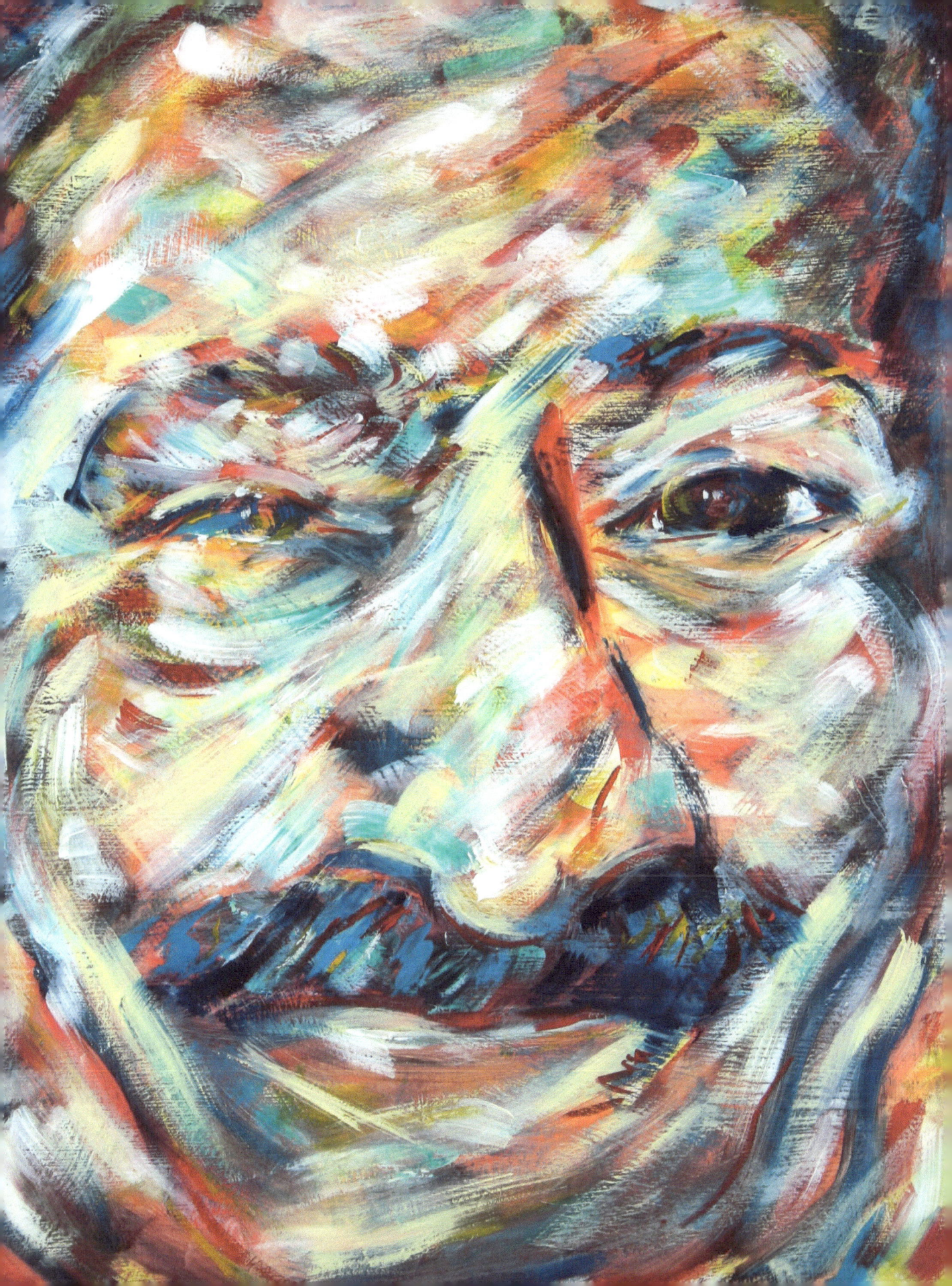

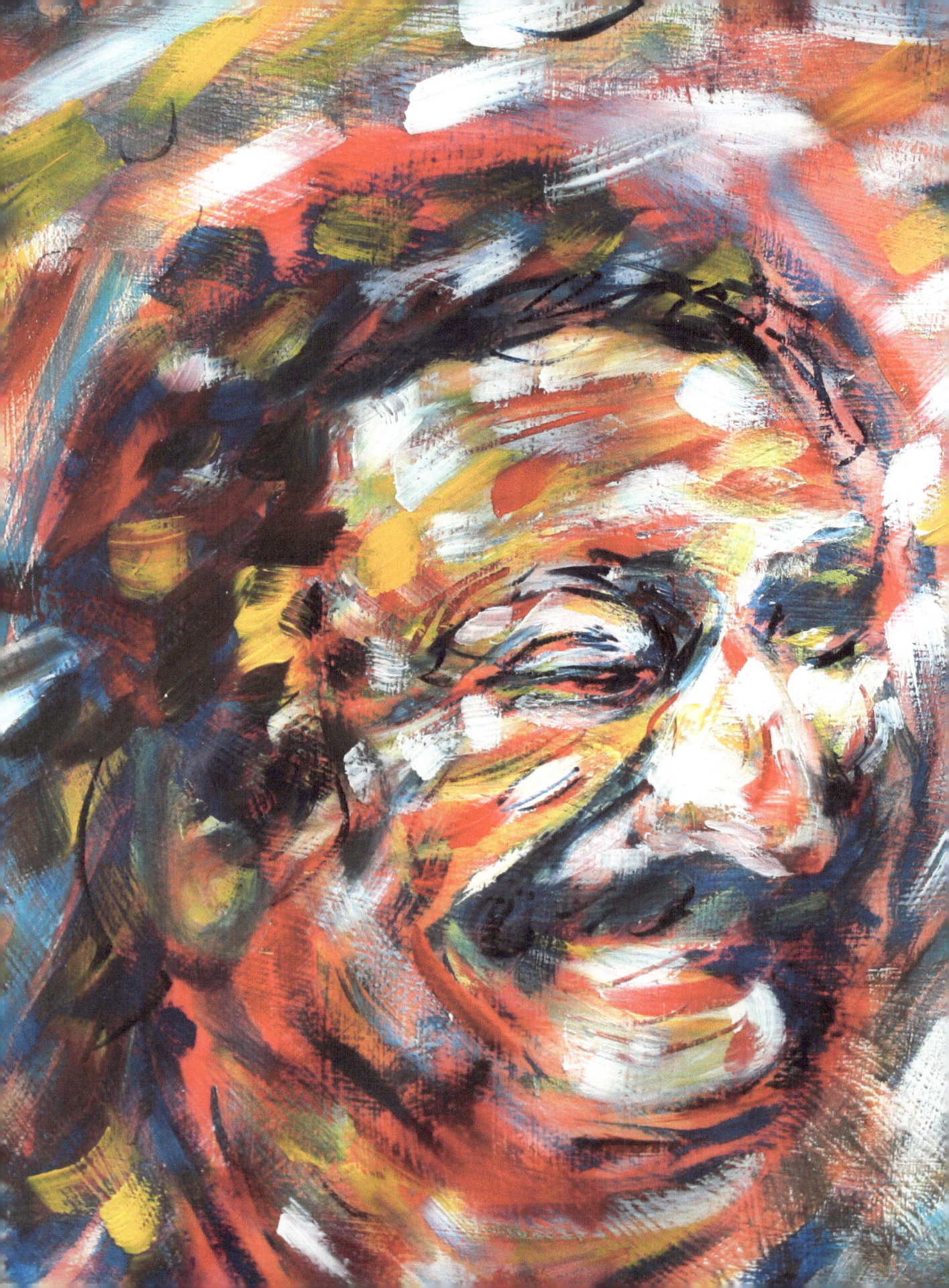

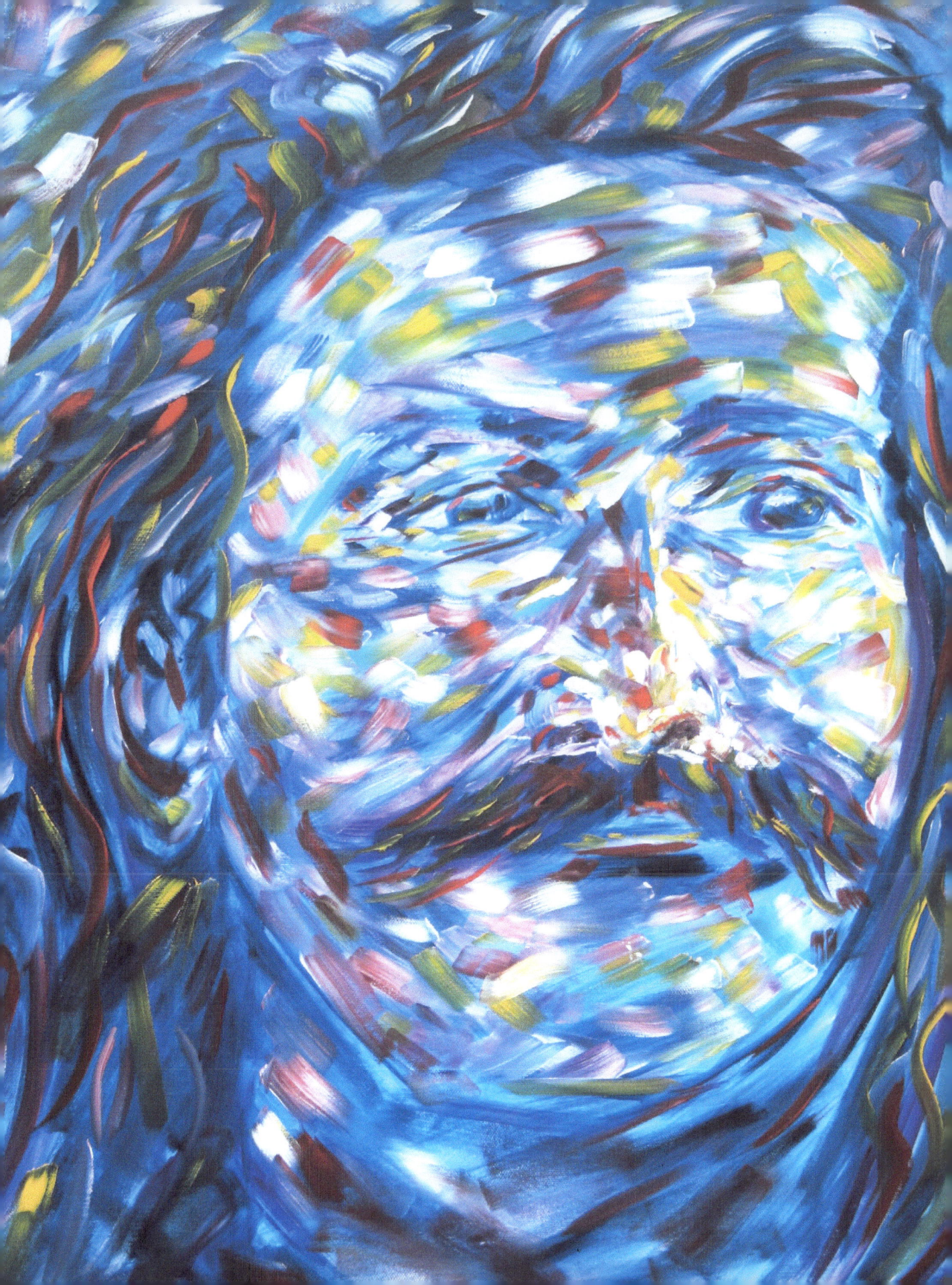

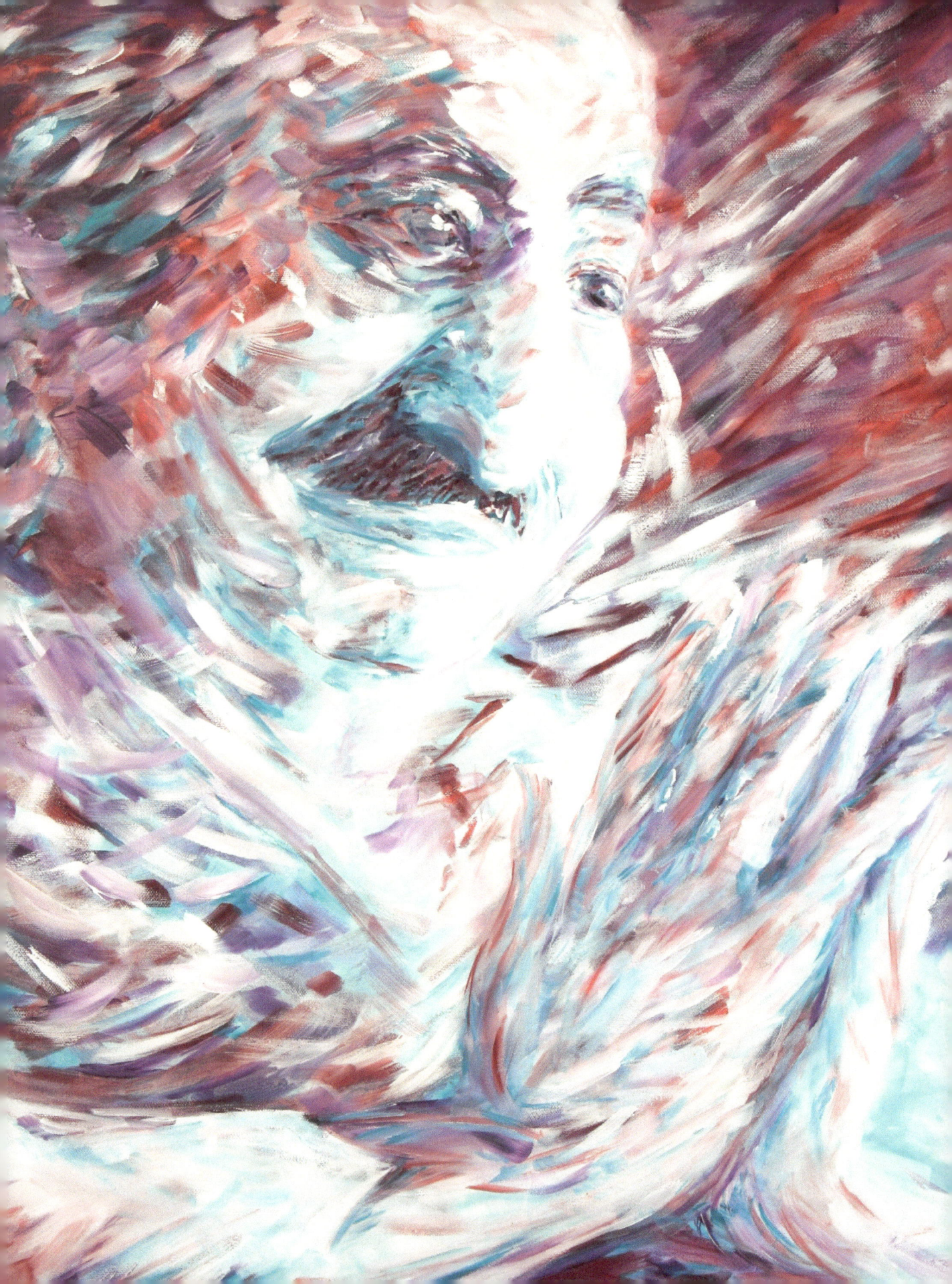

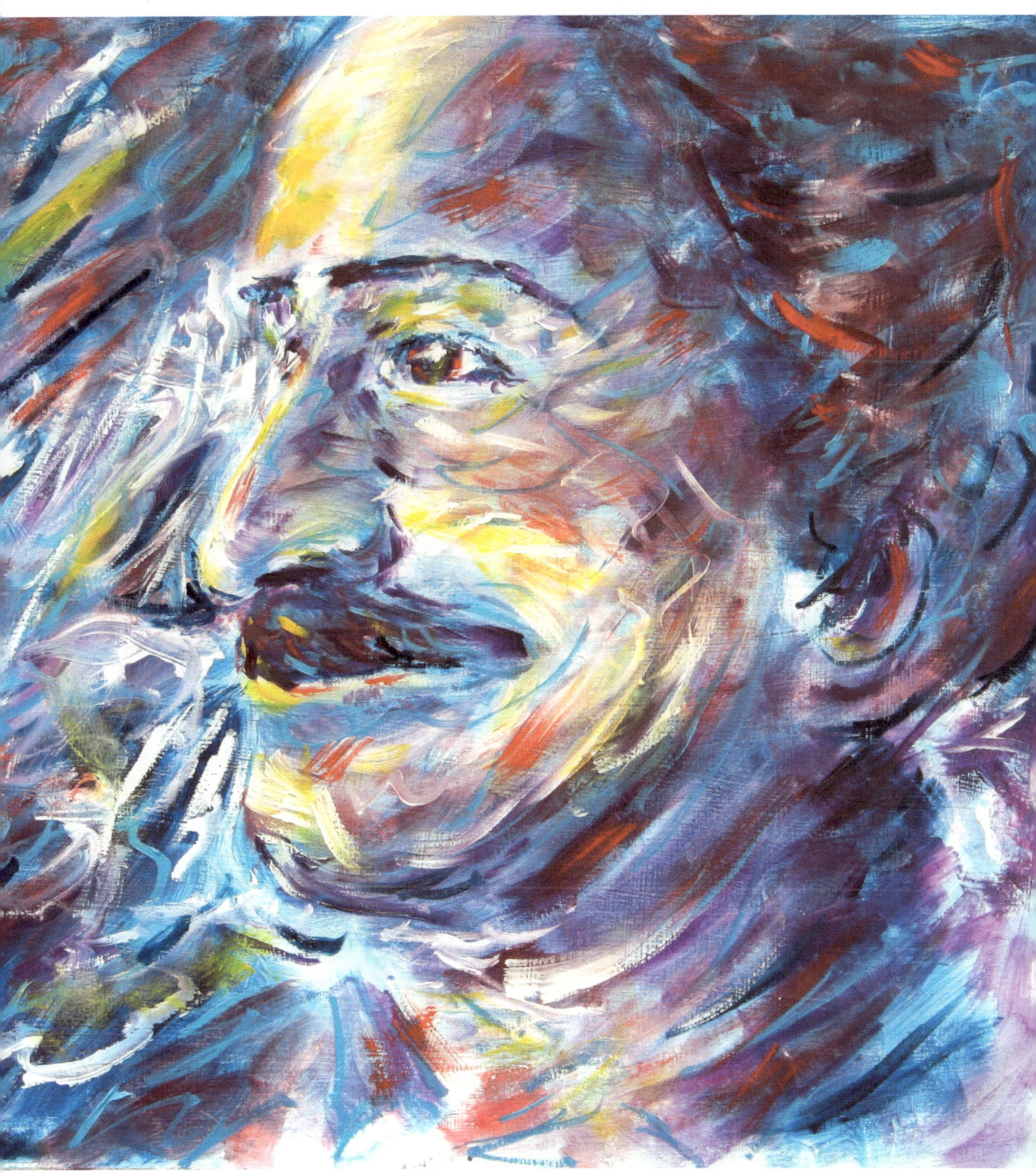

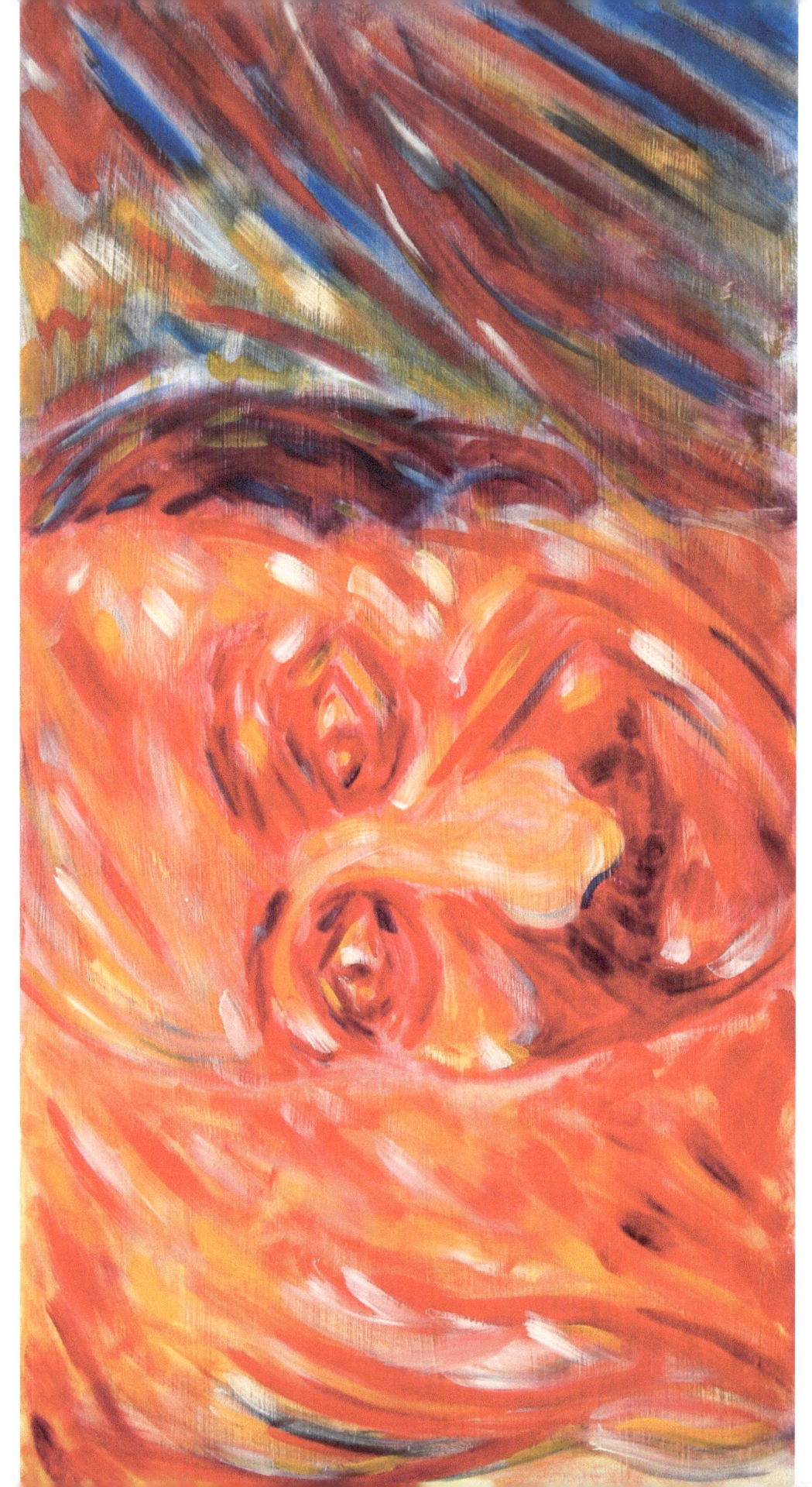

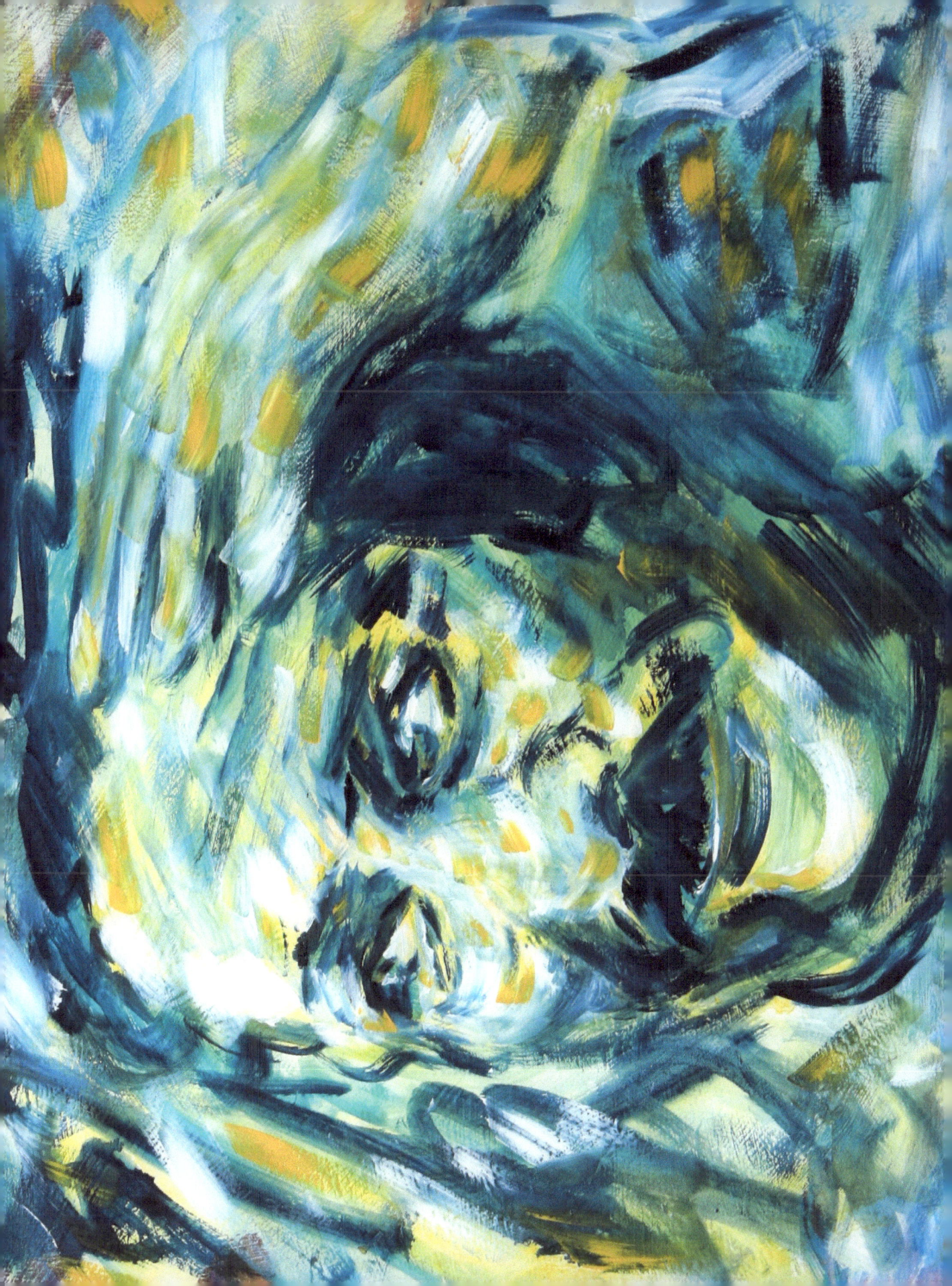

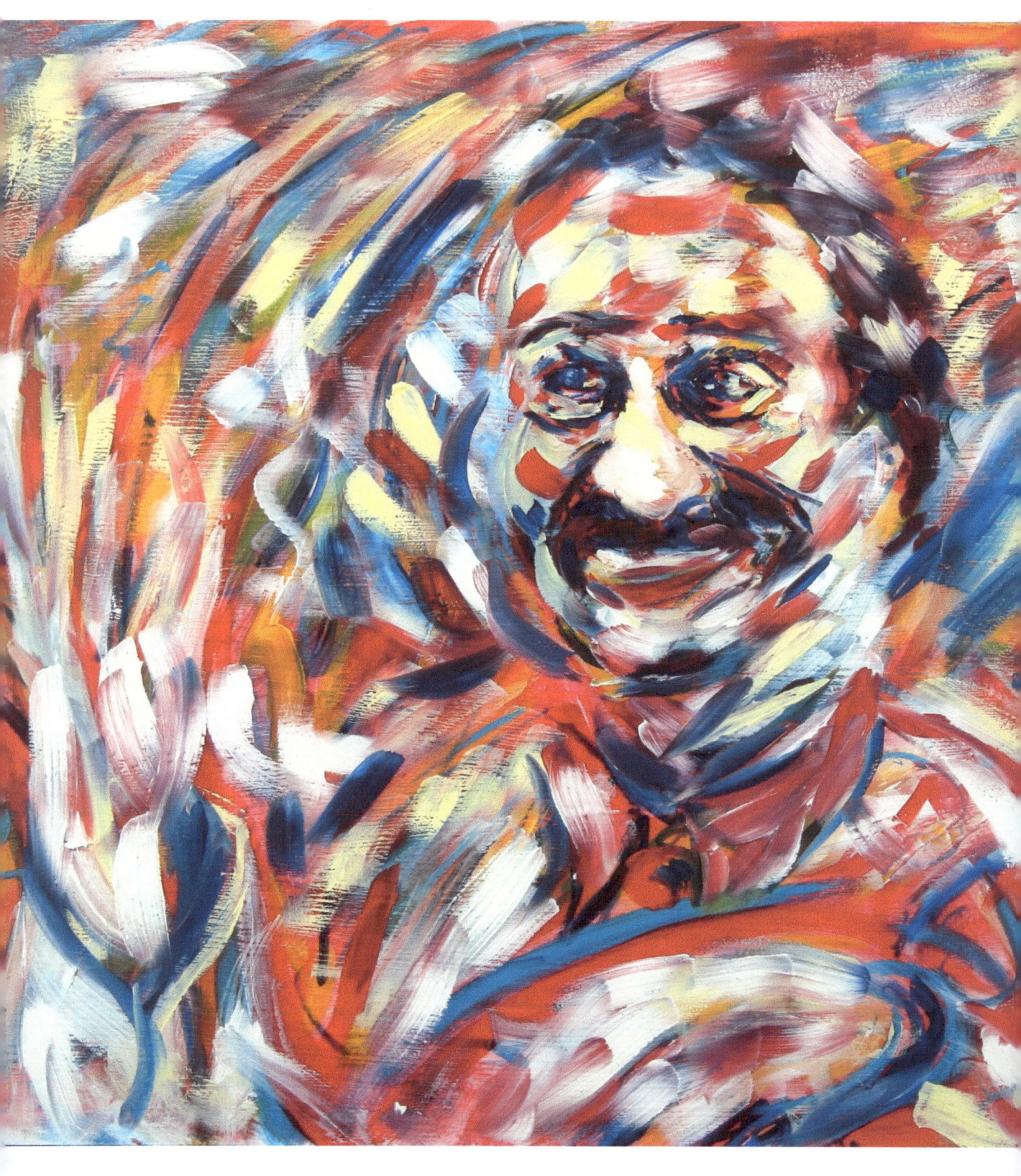

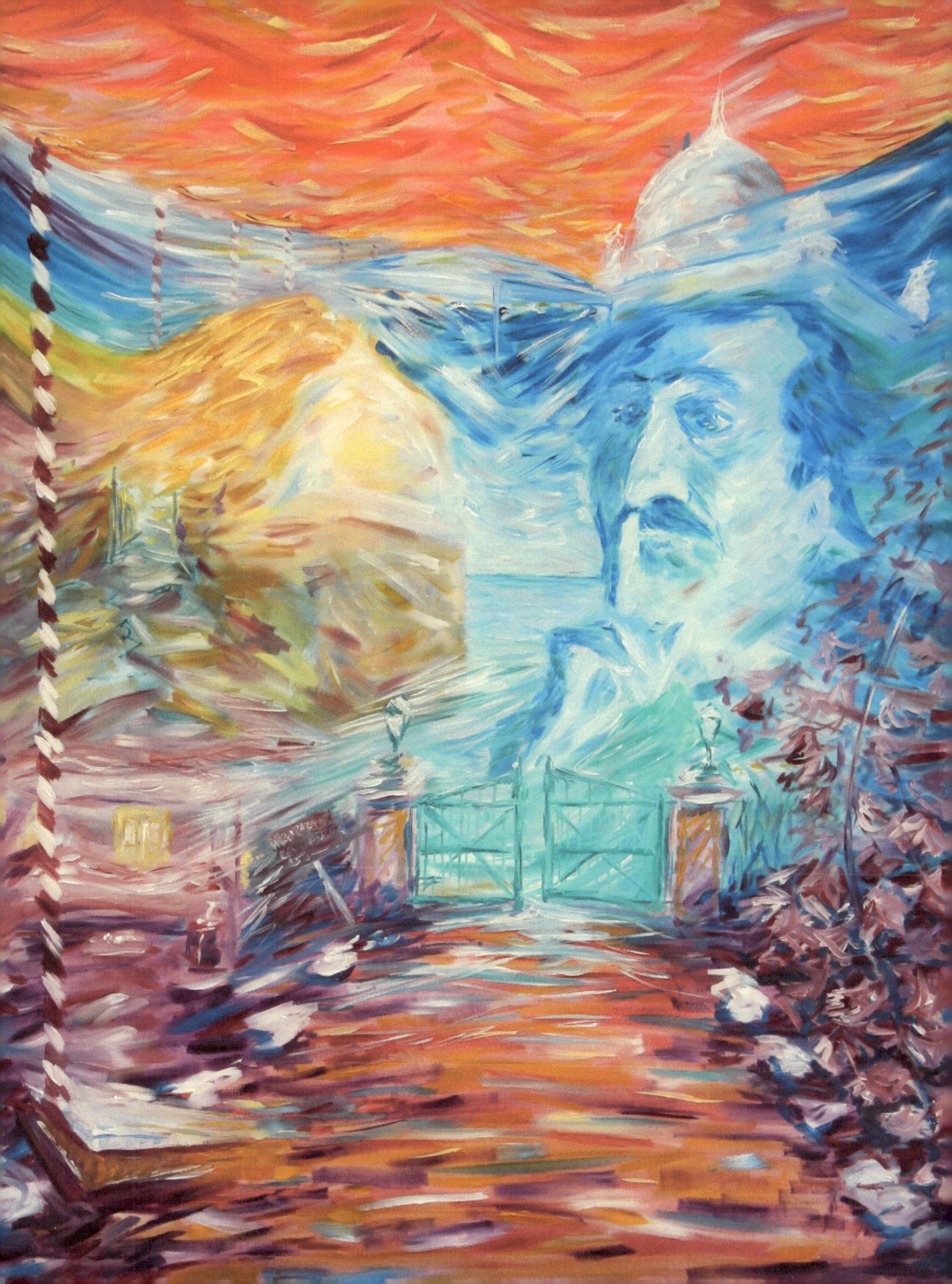

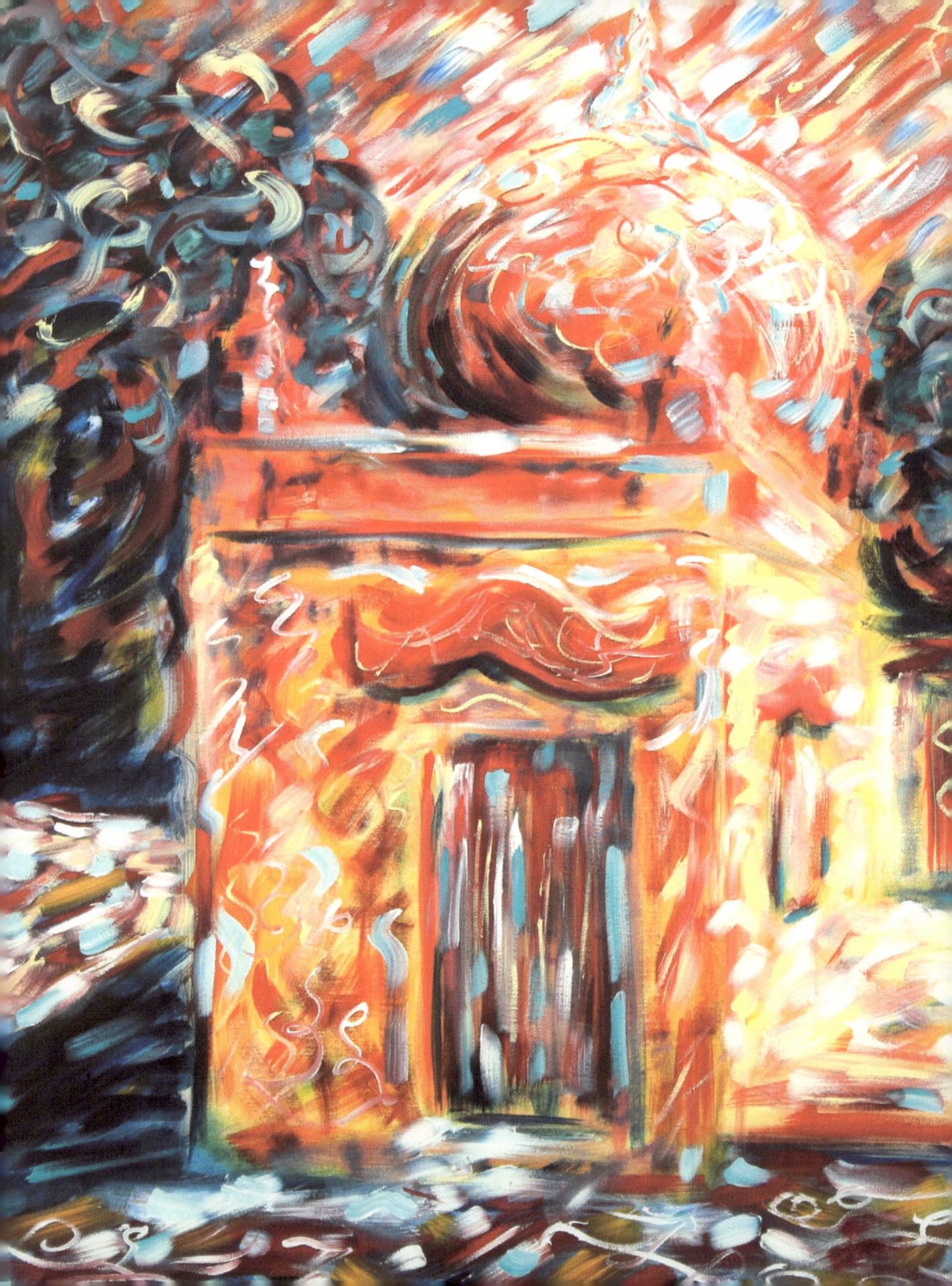

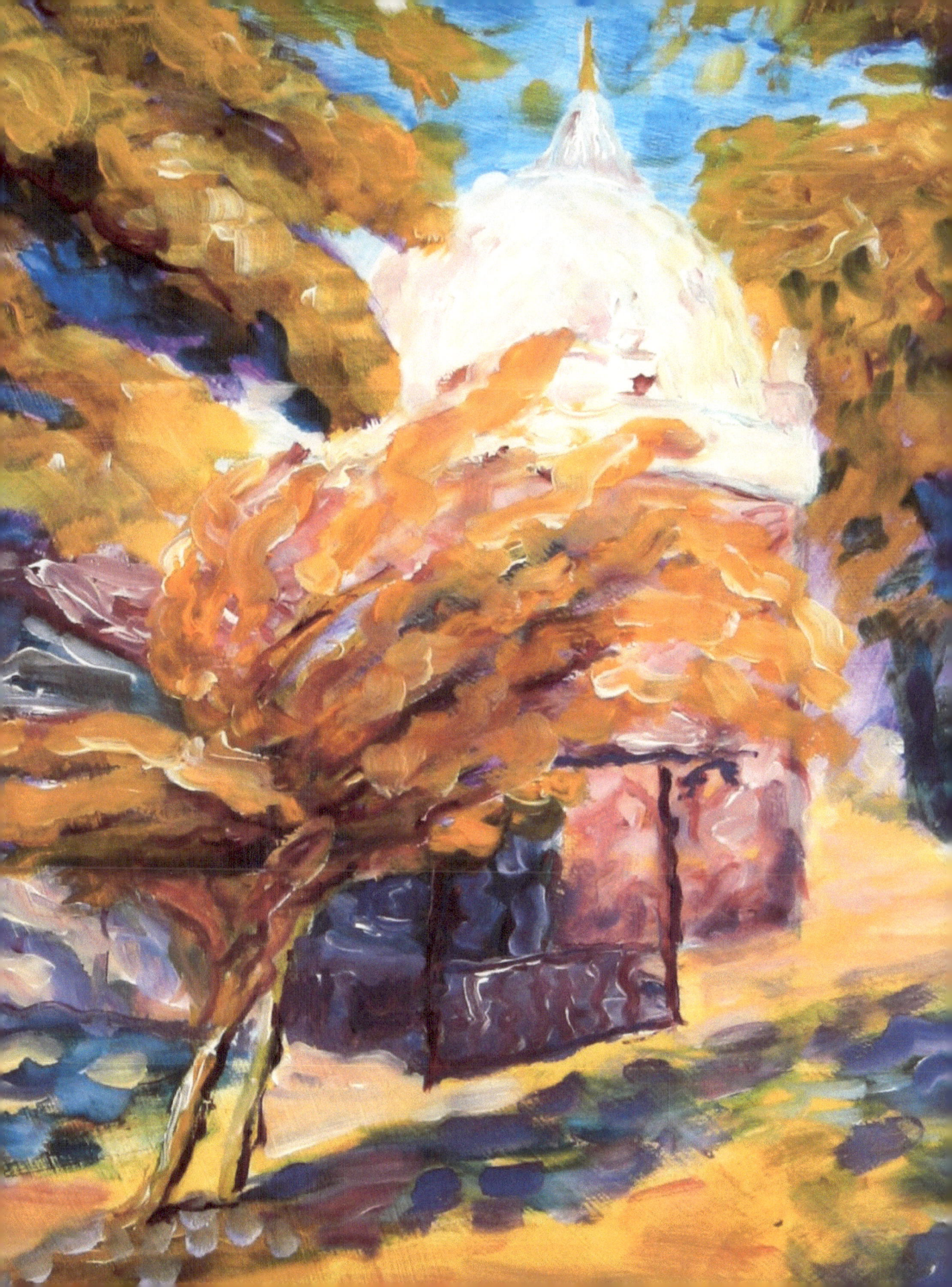

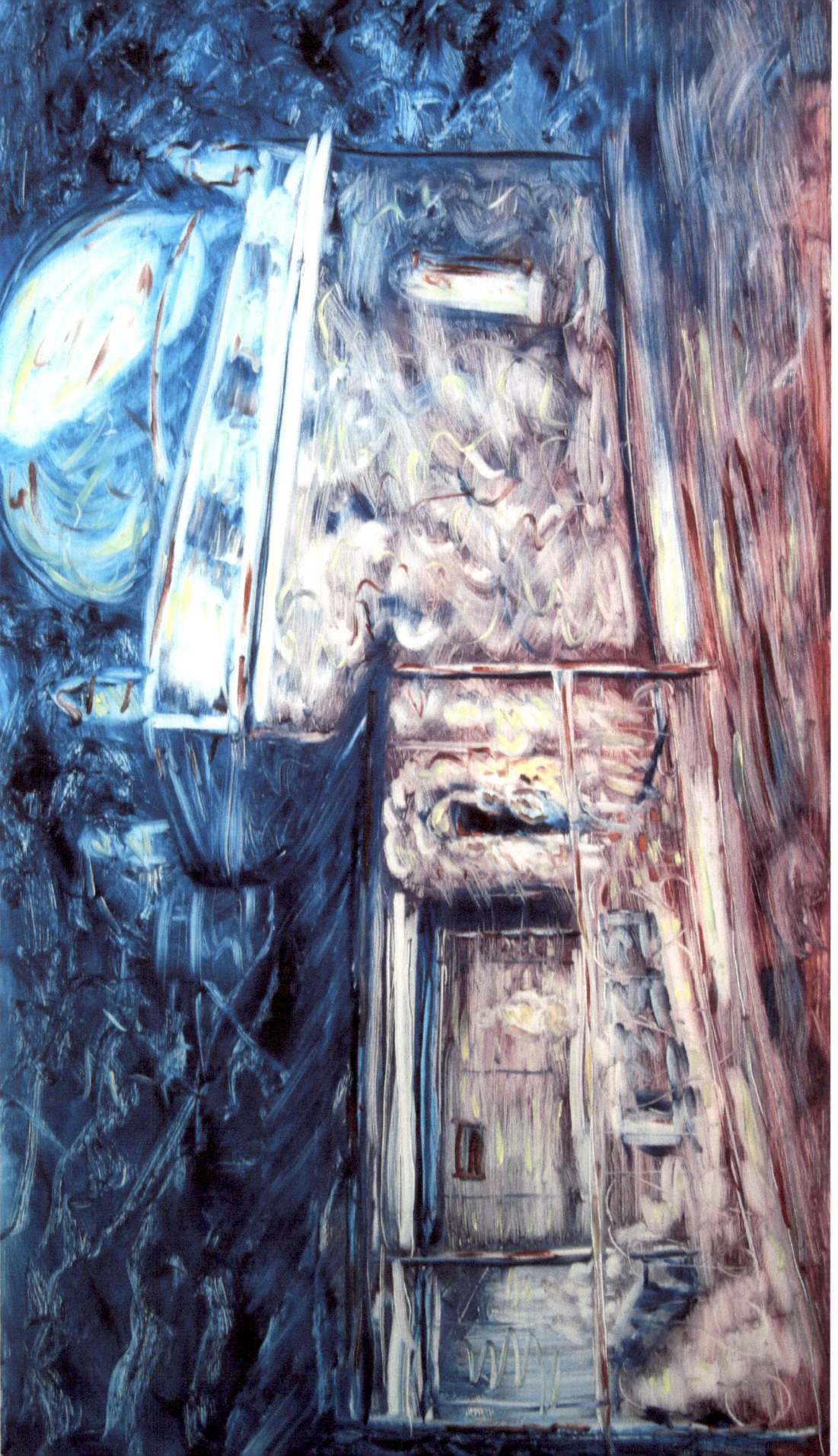

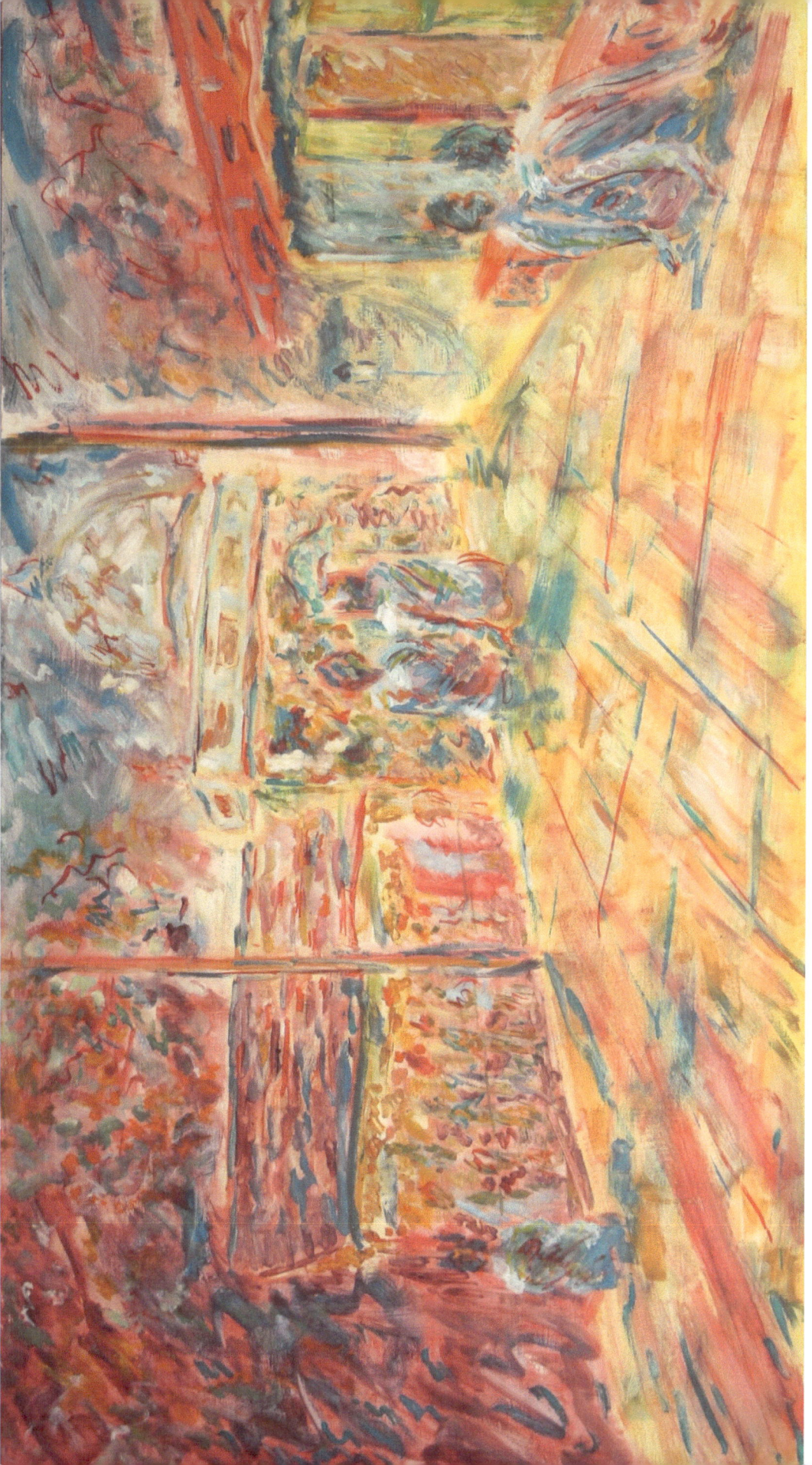

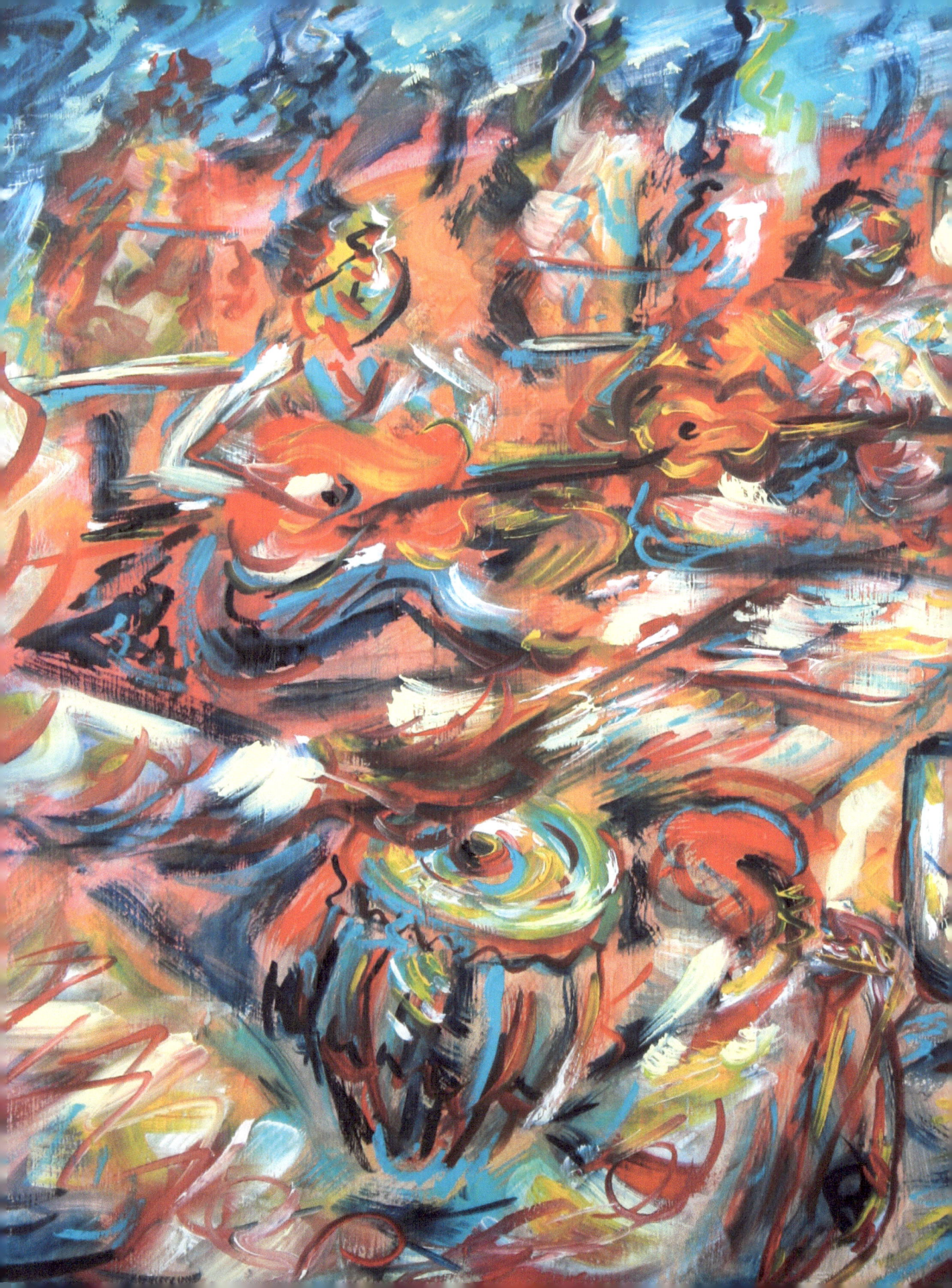

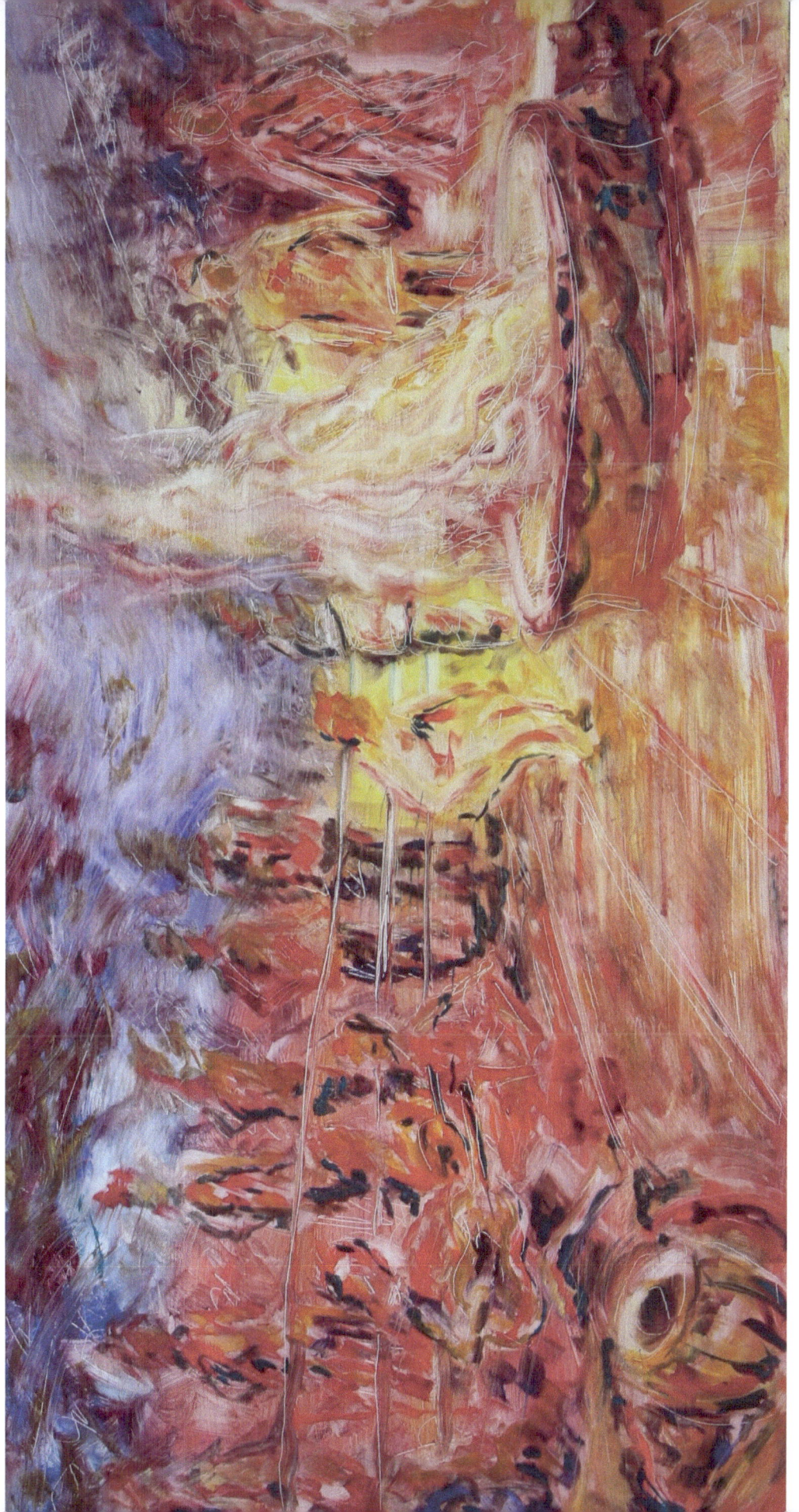

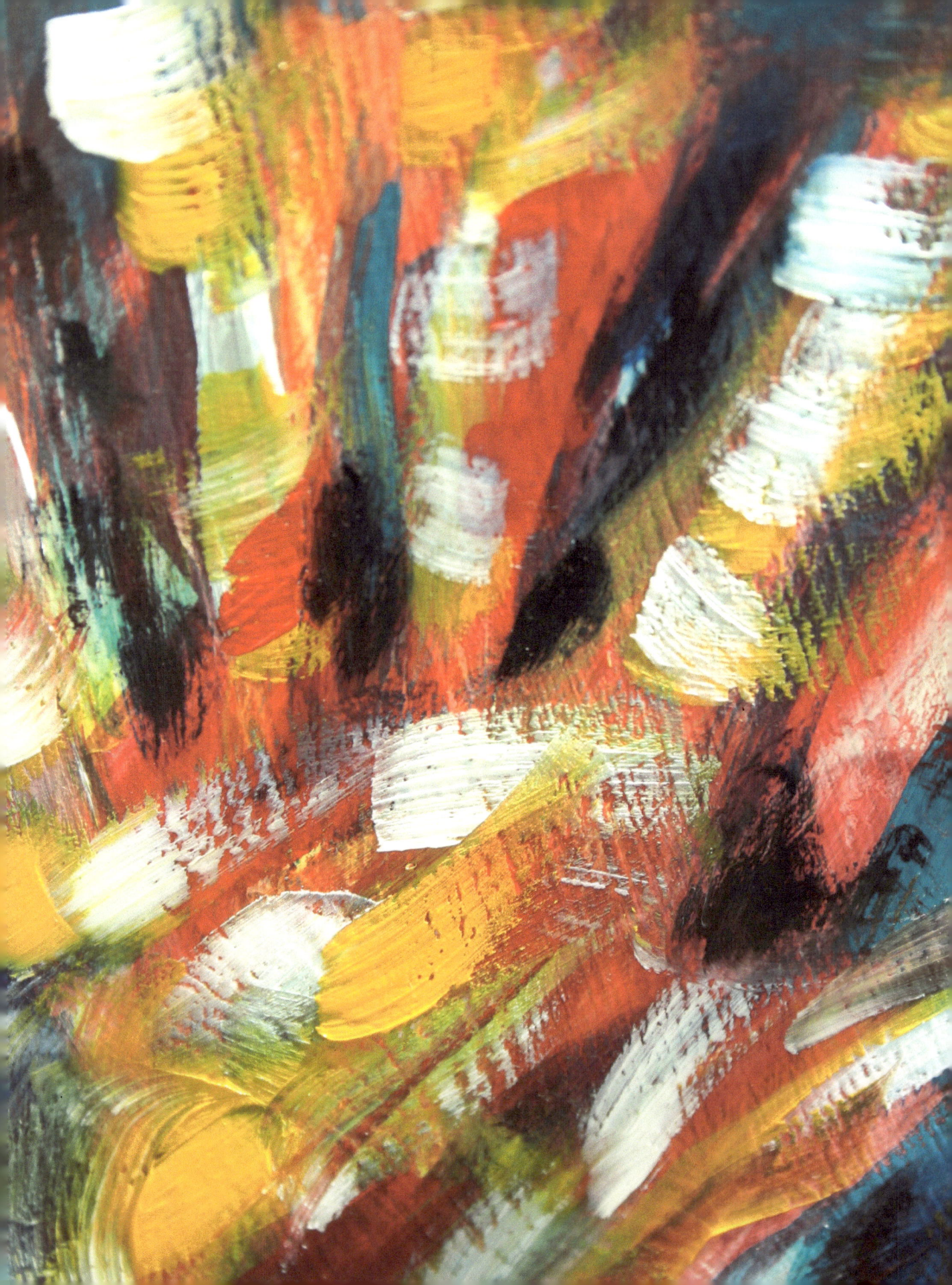

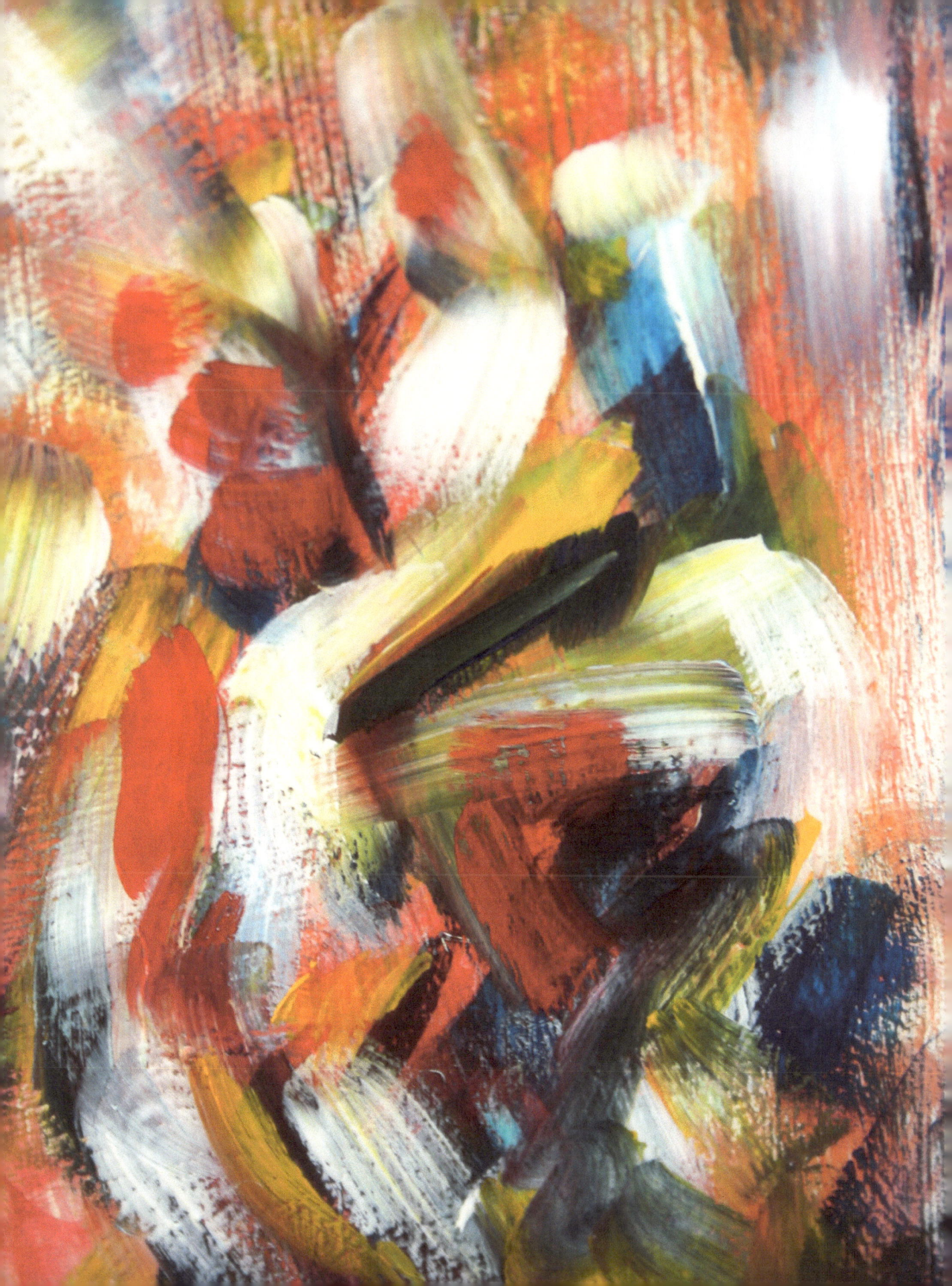

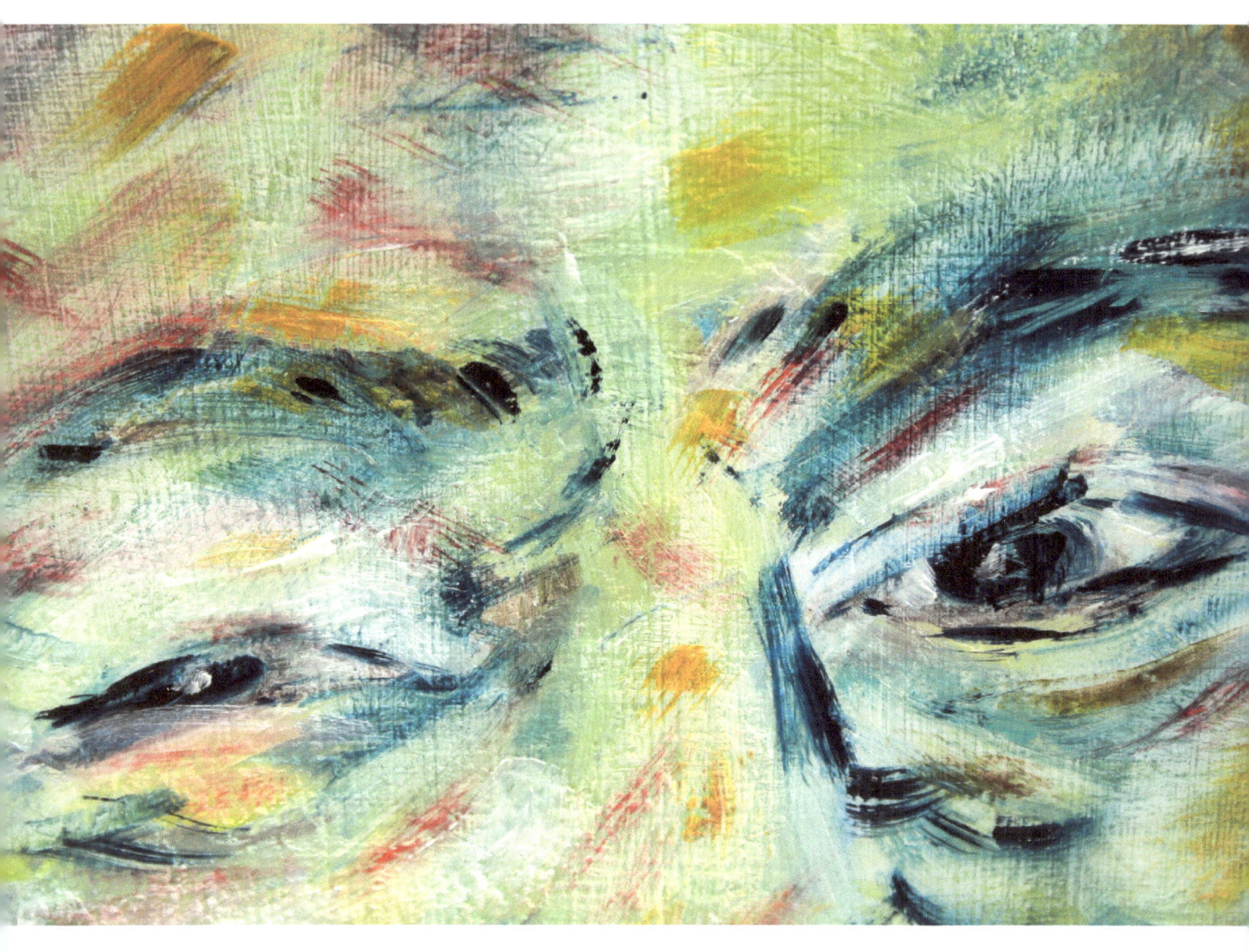

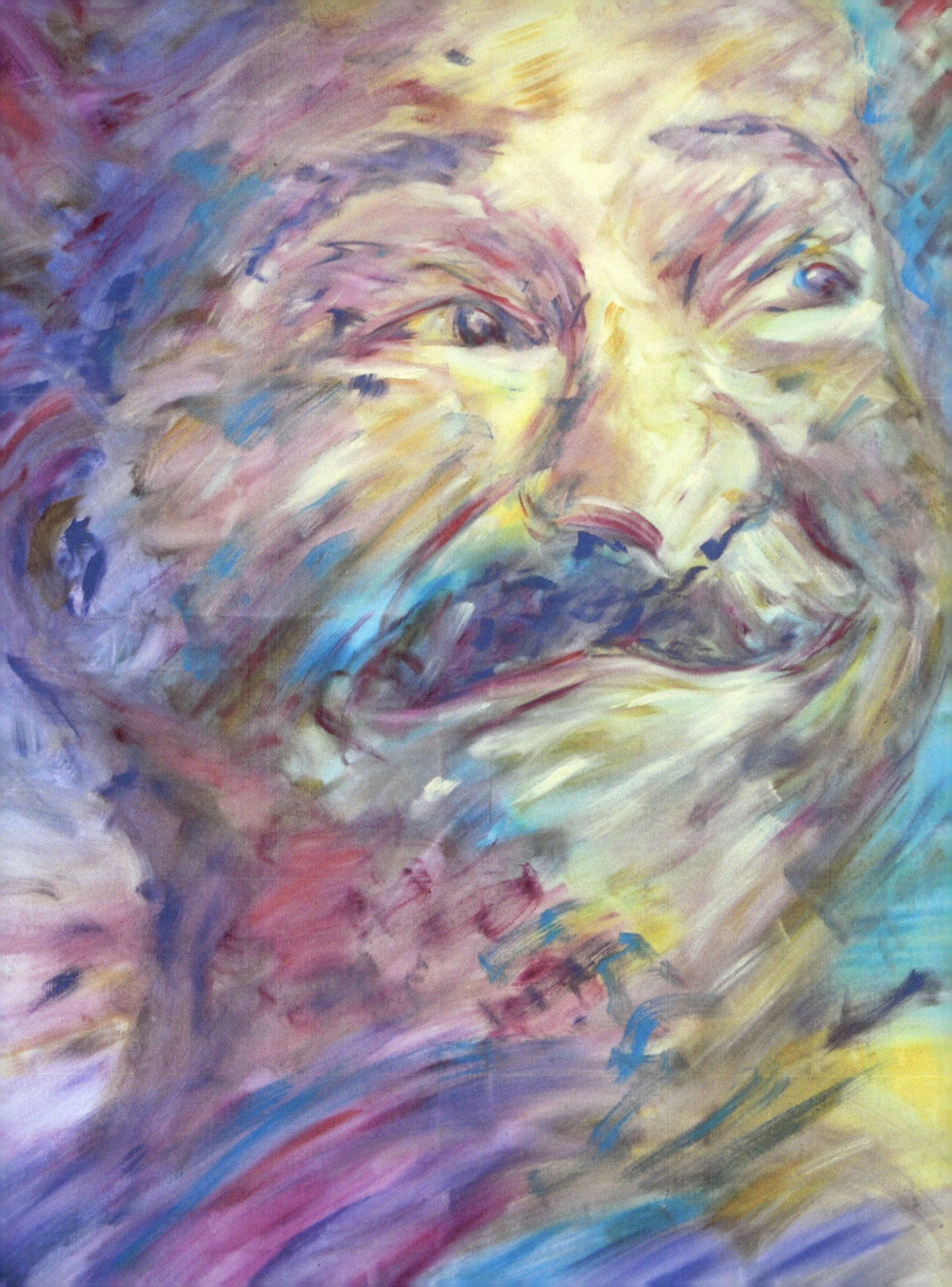

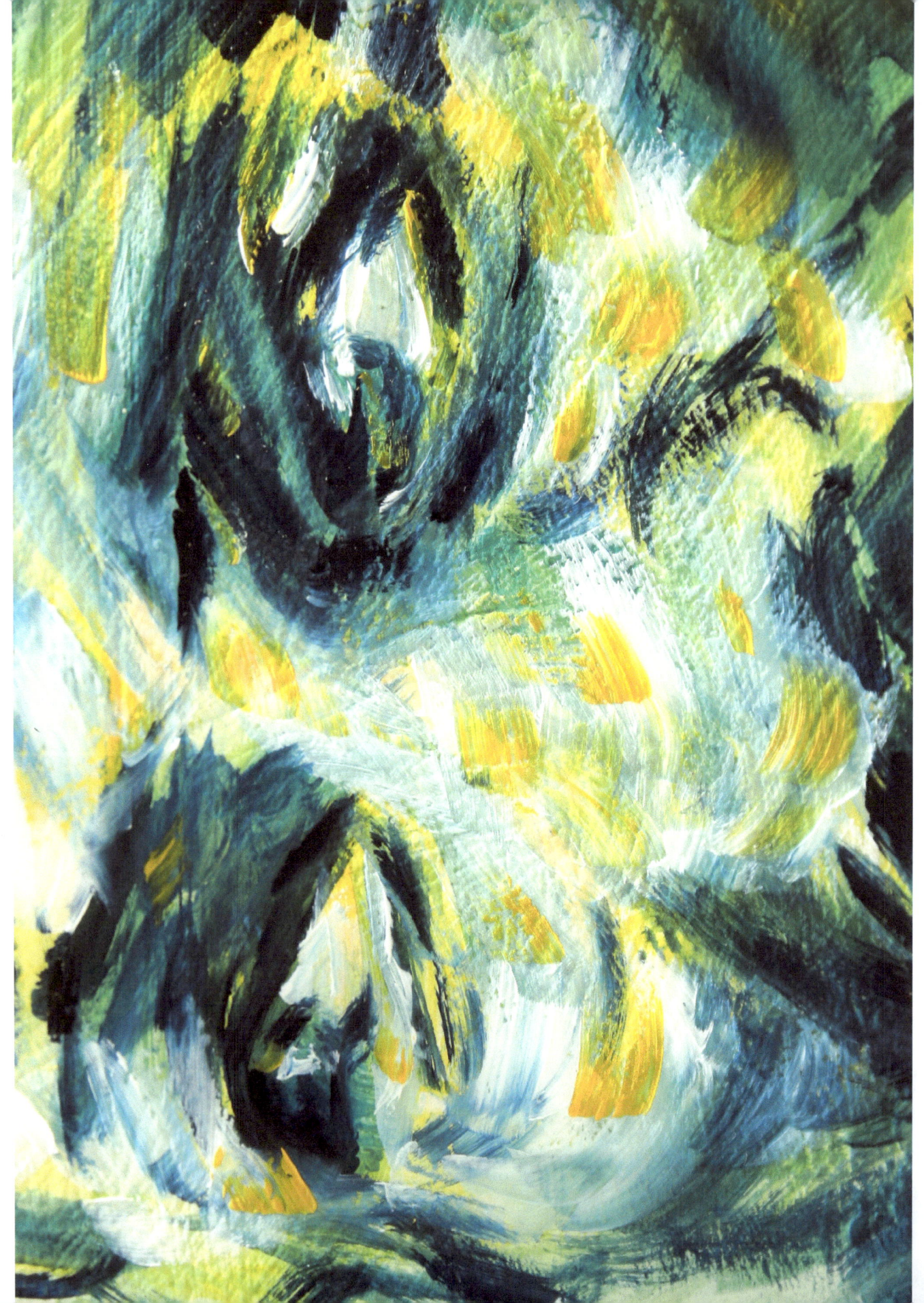

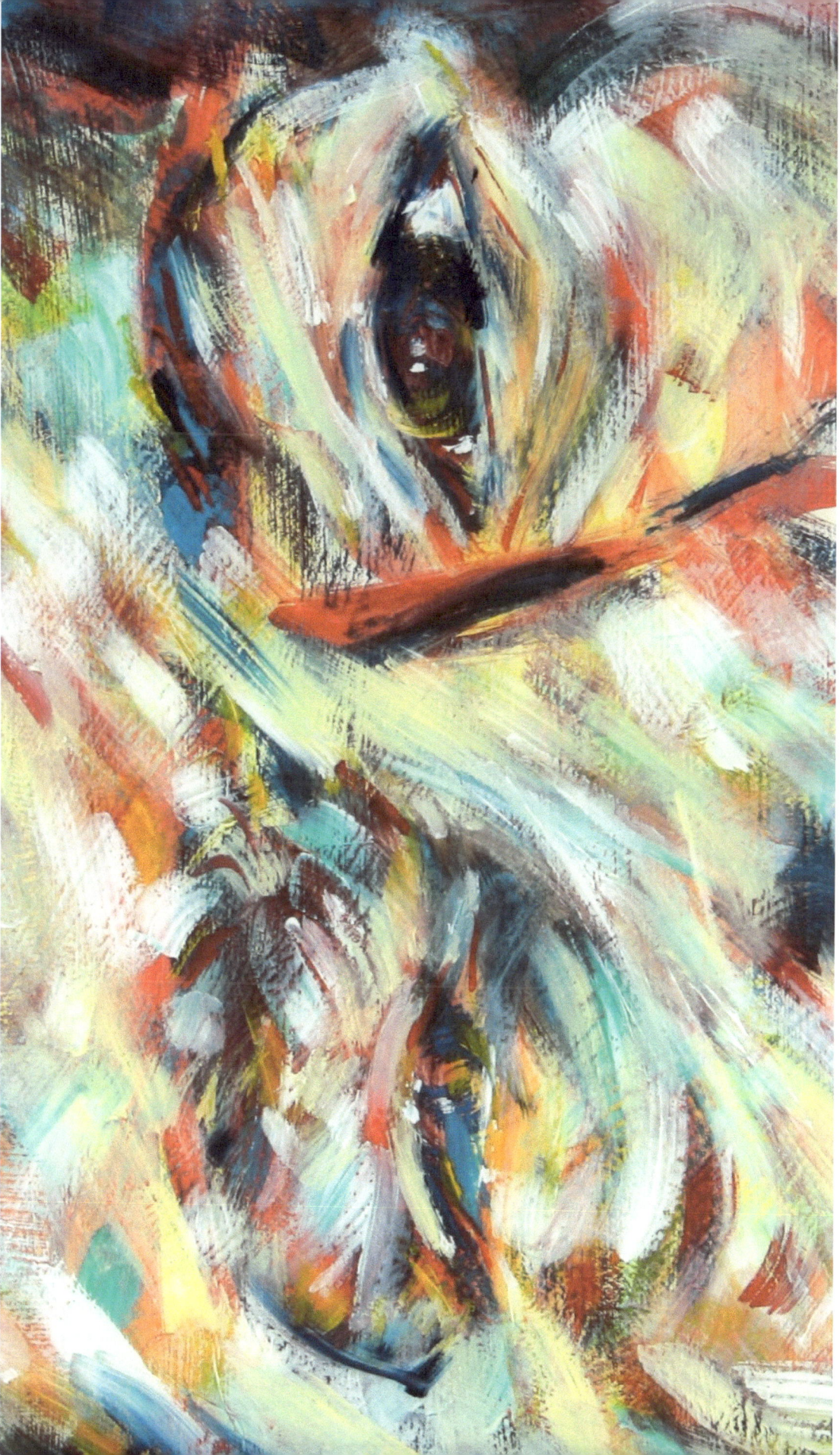

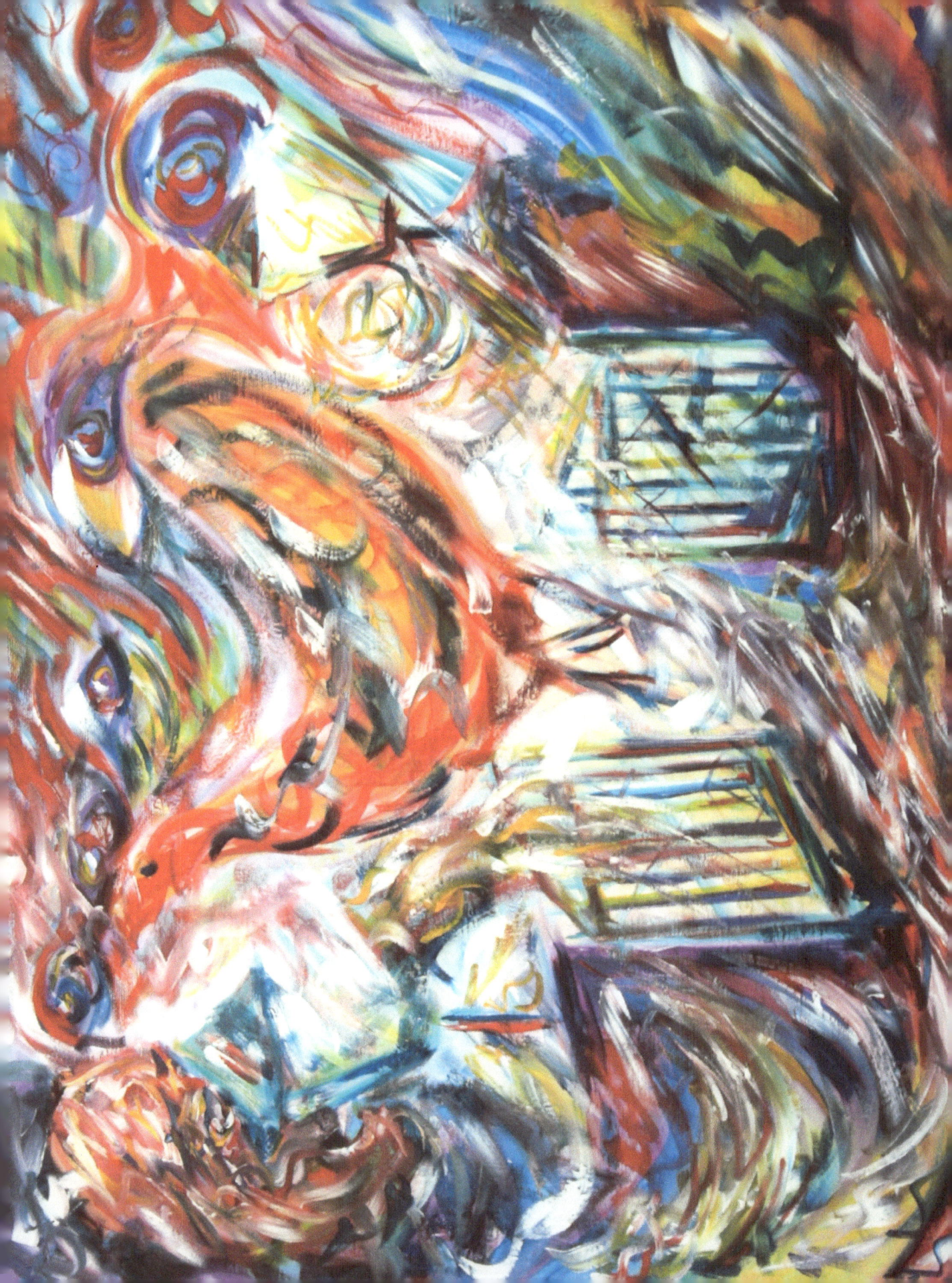

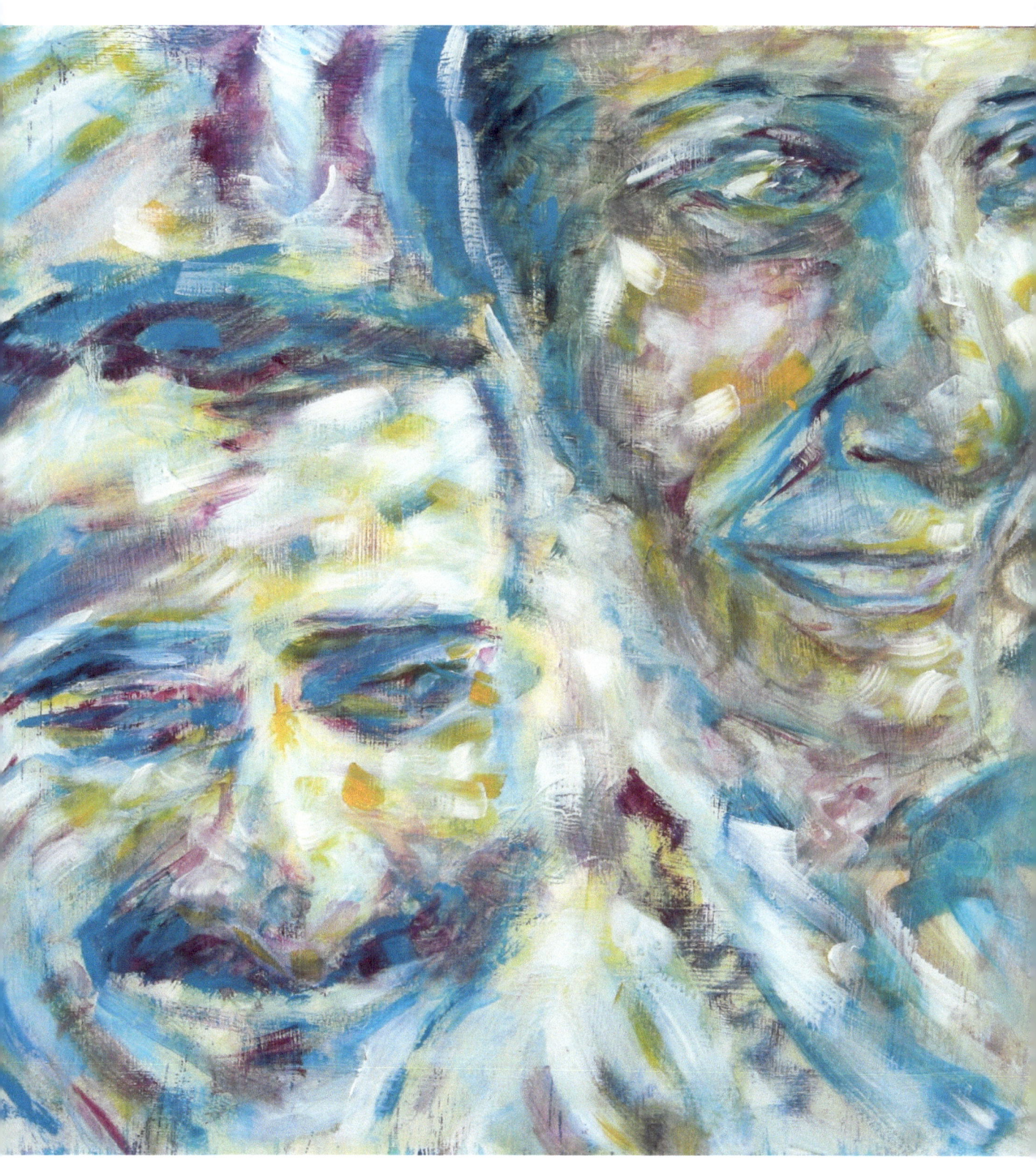

Catalogue 2008 - petecaswell.co.uk

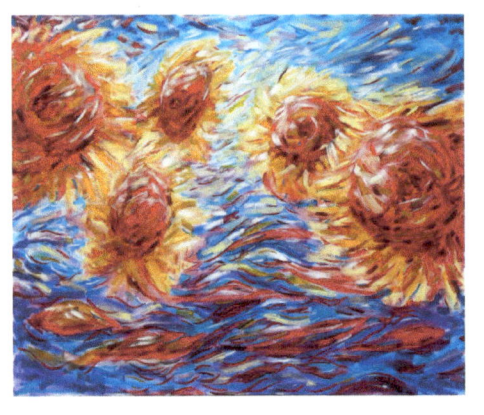
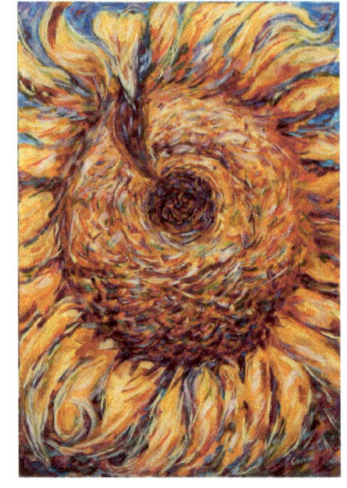
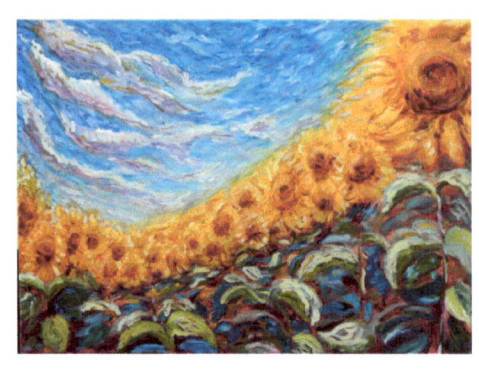
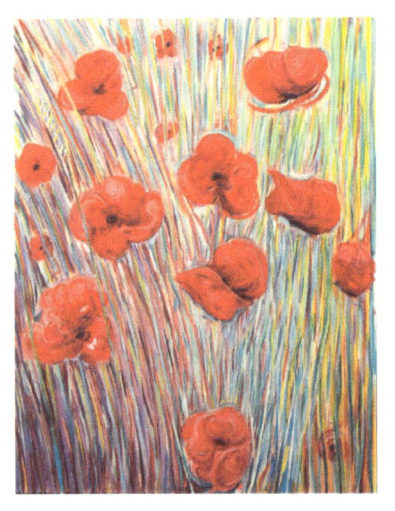
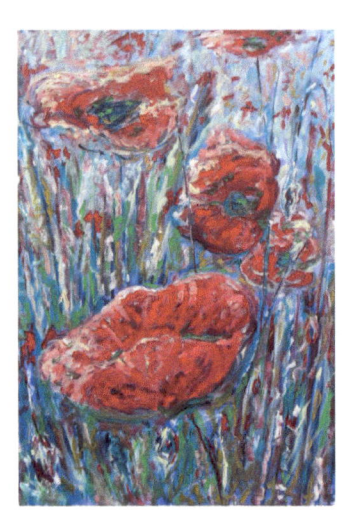
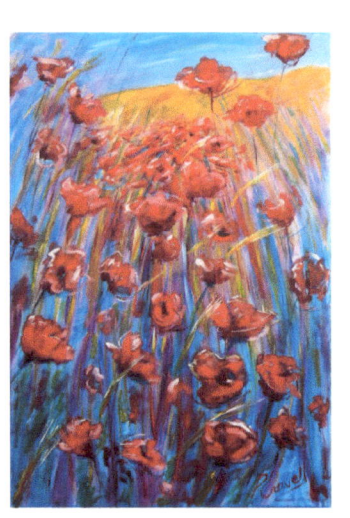
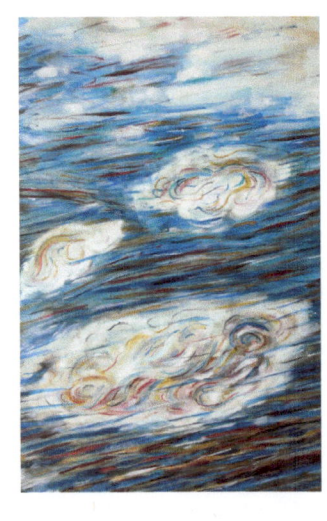
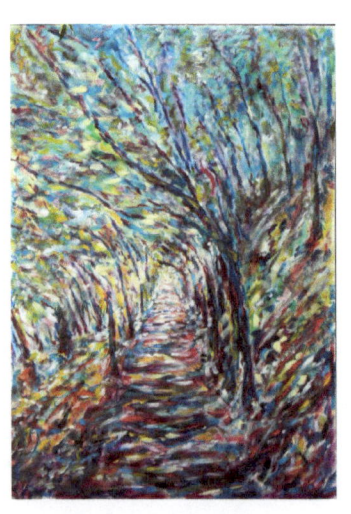
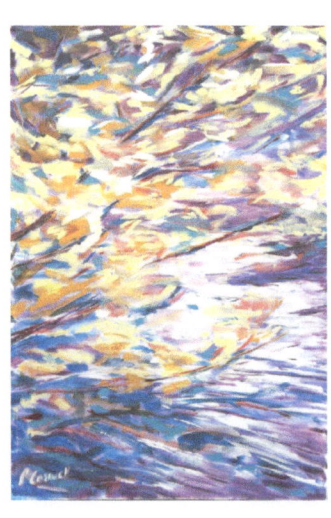

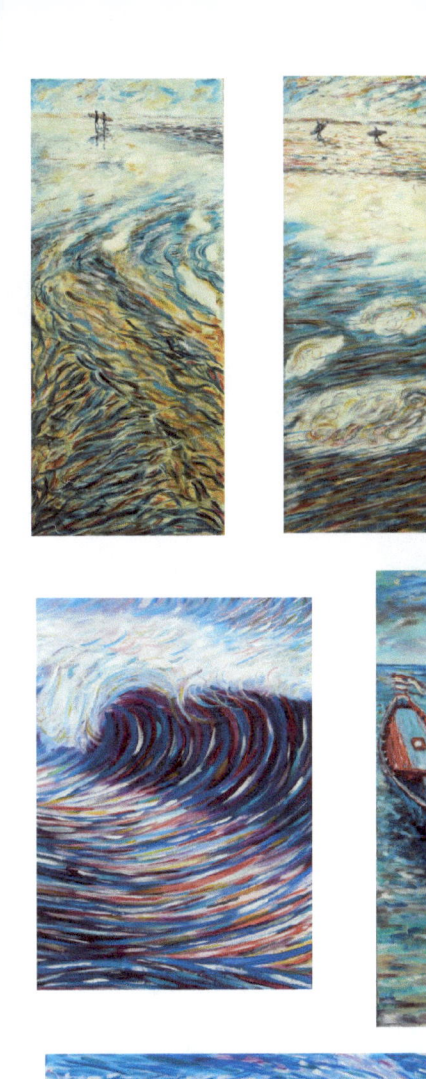
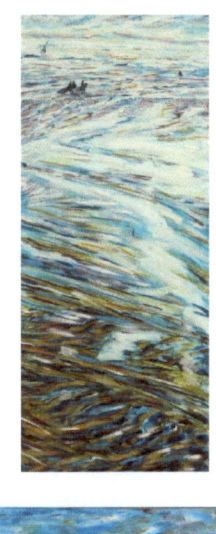
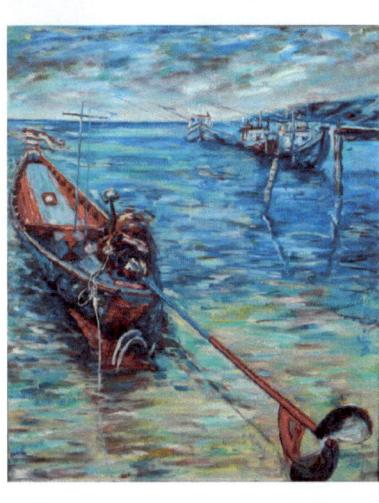
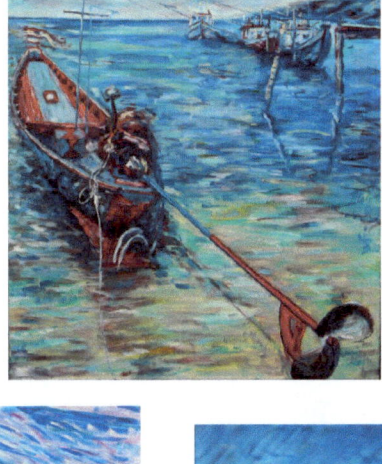
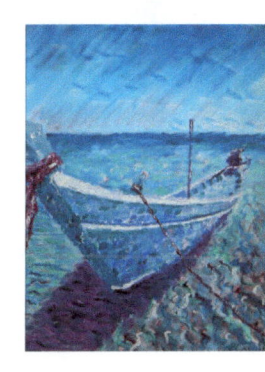
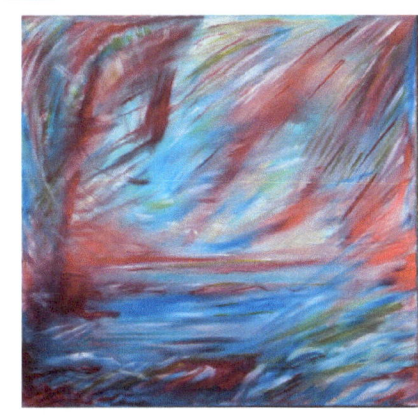
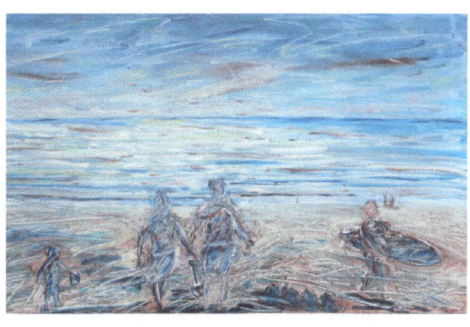
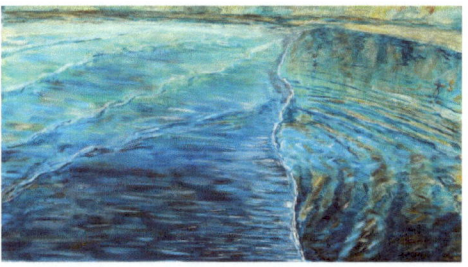
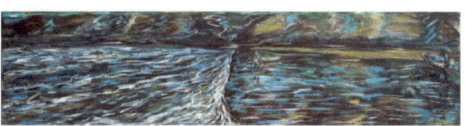
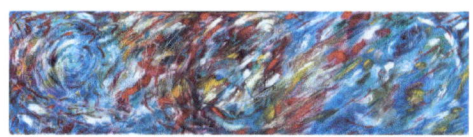
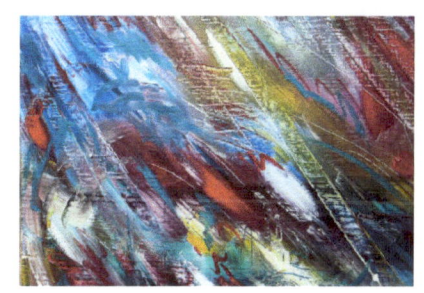
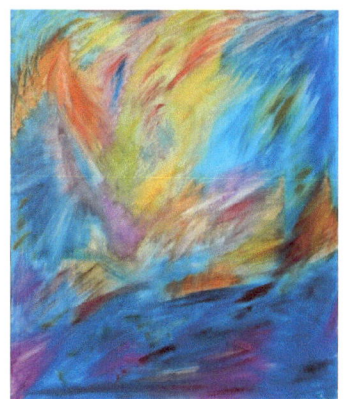
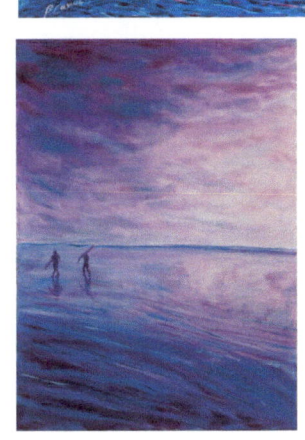

PETE CASWELL

Paintings, prints and books can be ordered direct from the authors own website:

www.petecaswell.co.uk

& www.lightspiritessences.co.uk

Paintings and prints can be viewed at Saunton Sands Studio in North Devon, England. Whilst an appointment is not always necessary it is always best to phone/email for an appointment.

Saunton Sands Studio

Moor Lane

Off Saunton Road

Braunton

N. Devon. EX33 1HG

United Kingdom

Copyright © 2007 Pete Caswell U.K

All rights reserved

Printed in USA, Europe and UK by P. Caswell

For permission to use extracts of this book or images please contact Pete Caswell

pete@petecaswell.co.uk

No part of this book mat be reproduced, stored in a retrieval system, or transmitted in any form or by any means, electronic, mechanical, photocopy, recording or otherwise without prior permission of the author, except by a reviewer who wishes to quote brief passages in connection with a review written for inclusion in a magazine, newspaper or broadcast.

Other Books which might interest you
published by Pete Caswell.co.uk

The Reference Guide to the qualities and disharmonies of the essences in the Light Spirit range made from the beautiful flowers of Meherazad and Meherabad in India. Includes the Emotional Balance Blends, the Aura and Room Sprays and the Individual essences. Each of the Individual Essences has an extensive description together with beautiful full page photographs. Produced and edited by Pete Caswell. Author Patricia Caswell. Further details on www.lightspiritessences.co.uk. A book of stunning photos of the flowers from the home of Indian Master, Meher Baba.

A fascinating musing on God through inner experience and insights, brought down to earth with cutting edge 21st century science. The book tries to explain universal phenomenon such as time, space and infinity and the meaning of life, using modern and ancient spiritual knowledge paralleled with modern science and practical examples. The book is full of powerful and moving impressionist paintings bursting with colour and bold brush strokes, to enliven the text. It's a lovely book for the coffee table, following on from the successful Mind Cracker book. Fun, modern and fast moving. Full of new ideas and ways of thinking. Also available in B&W novel.

A truly beautiful and inspiring book, challenging the dominance and hypocrisy of our mind centred world, prompting us to live more in the heart and trust our intuition. As we move from our mind to our heart we learn to live in the present and let go of old patterns and fears, to embrace life. Beautiful, vibrant, colourful paintings by the author, illuminate the pages. Riddles of life, mind and soul reminiscent of Rumi's poems and Lao Tzu's Tao Te Ching's texts inspire the reader. Also available in B&W novel size fromat.

Beautiful full colour book of Pete Caswell's favourite impressionist paintings(2006). Full paintings and close up images of abstract sections, brush work and strokes of colour. A4 size for those who love to look through the colourful images of Pete's popular paintings.

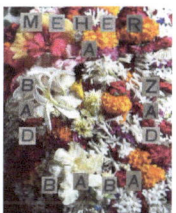

Book of beautiful photographs from the author's latest photography assignment in India in 2006. Photos from Central West India including Meherabad, Meherazad, Pune, Happy Valley, Seclusion Hill, & Pimpalgaon Lake, all taken during an extremely wet, wet season. Includes some amazing Dhuni photos. The back 7 pages have some of the author's paintings from the area.

A rather seductive and deceptive book that draws you in, with not only the personal aspects of the author's life, but engages the reader's attention with amusing humour. Thought provoking bite size chunks, perfect for reflection and contemplation, on intuition, inspiration and living without the mind. Offering some clues and clarification, the author brings in his personal experience of the subject and sets out what intuition means or has meant set against his actual experience. Removes the mystery from Spirituality with real life examples. A book of Pete Caswell's modern day experience of following Meher Baba's inner guidance. Full color photos on every page taken in Meherazad & Meherabad. Slightly more abstract images than the photo book above, but a real treasure to remind you of this special place. Also available in B&W novel size format.

All the books are full colour and make a great addition to the coffee table. The colours, forms and images are a wonderful source of inspiration, a luscious backdrop to the provoking text.

petecaswell.co.uk mindcracker.co.uk lightspiritessences.co.uk spiritual love poems.co.uk

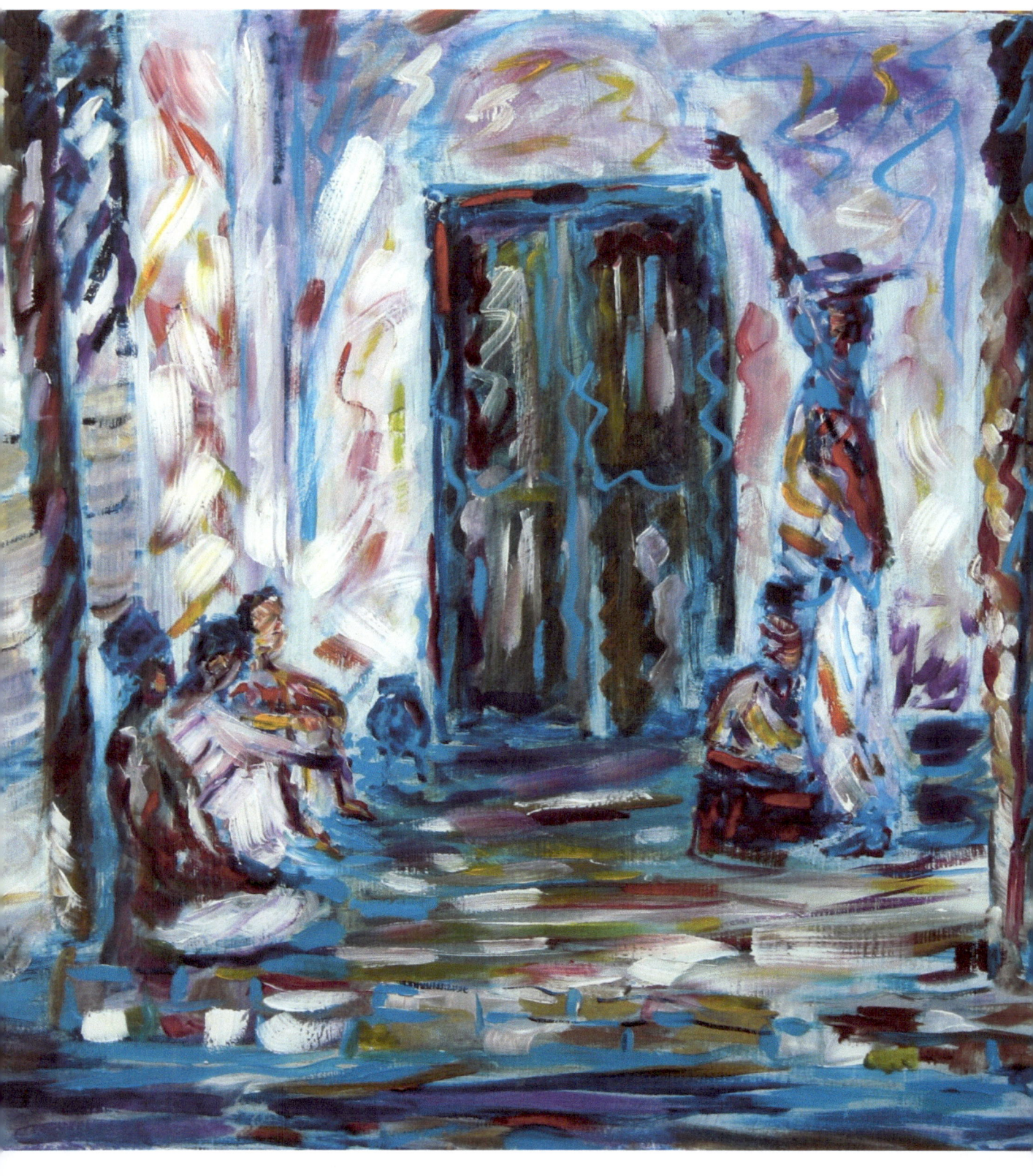

www.ingramcontent.com/pod-product-compliance
Lightning Source LLC
Chambersburg PA
CBHW051107180526
45172CB00002B/810